IMAGES
of America

CANTON
ENTERTAINMENT

ON THE COVER: The Barnum & Bailey Circus is pictured on parade in the 200 block of South Market Avenue on May 25, 1904.

IMAGES
of America

CANTON
ENTERTAINMENT

Kimberly A. Kenney

Copyright © 2013 by Kimberly A. Kenney
ISBN 978-1-4671-1084-6

Published by Arcadia Publishing
Charleston, South Carolina

Printed in the United States of America

Library of Congress Control Number: 2013937020

For all general information, please contact Arcadia Publishing:
Telephone 843-853-2070
Fax 843-853-0044
E-mail sales@arcadiapublishing.com
For customer service and orders:
Toll-Free 1-888-313-2665

Visit us on the Internet at www.arcadiapublishing.com

This book is dedicated to all of the people and organizations in Canton who have provided entertainment opportunities for more than two centuries. Then or now, there has never been a reason to be bored in this town!

Contents

Acknowledgments		6
Introduction		7
1.	Amusement Parks	9
2.	Circuses, Celebrations, Fairs, and More	27
3.	Clubs	45
4.	Cultural Organizations	55
5.	Hotels	67
6.	Opera Houses and Theaters	75
7.	Restaurants	91
8.	Shopping	107
9.	Sports	119

Acknowledgments

A book like this requires the help of many people to make it a success. First, I would like to thank my coworkers at the McKinley Presidential Library & Museum for their support of this project. Unless otherwise credited, the photographs in this book are from the museum's collection. Special thanks to *Repository* journalist Gary Brown, who assisted with research and promoted the call for photographs that made this book possible. The archives at the McKinley Presidential Library & Museum are full of Gary's "Monday After" columns, which provided a wealth of information for me. Char Lautzenheiser, director of the Canton Classic Car Museum, allowed me to poke around their vast collection of Canton memorabilia, looking for anything related to entertainment. Kathy Fleeher and Al Albacete of the Canton Museum of Art, Georgia Paxos at the Palace, and Michelle Mullaly and Lisa Boyer with the Canton Symphony Orchestra provided photographs and information about their organizations. Valerie Kline, reference librarian at the main branch of the Stark County District Library, sifted through stacks of books and mountains of files to find tidbits of information I needed to complete my research on some of the most obscure entertainment venues in this book. Thank you to the following individuals who brought me photographs from their personal collections or shared information with me: Barbara Abbott (Canton Food Tours), Joyce Bair, Carolyn Baird, Kent Bedford, John Butler, Rosemary Diamond, Richard W. Fulton, Bill and Judy Gouge, Leslie Gruber, Linda Herald, Becky Lloyd, David Lloyd, Al Longbrake, Michelle McCartney (Chateau Michele), Gary Nist, Jerry Novak, Linda Todd, Wanda Tull, and Dawn Walter. Last, but not least, I would like to thank my husband, Christopher Kenney, for his unwavering support, editing, research assistance, and homemade chocolate-chip cookies.

If you do not see your favorite restaurant, store, or entertainment venue in this book, it is likely because I could not locate a photograph of it. If you have one, please contact me at the museum at 330-455-7043 or curator@mckinleymuseum.org. We are always looking to build our collection and preserve more of Canton and Stark County's history.

INTRODUCTION

Throughout history, humankind has always tried to make time to rest, relax, and have a little fun. Even while carving a community in the wilderness, pioneers in this area organized singing societies to entertain themselves. As the population grew, restaurants, stores, hotels, theaters, clubs, sporting events, and celebrations began to take shape.

John Shorb opened Canton's first store in 1807, just two years after the town was established, on the southwest corner of Market Avenue and Second Street. Since the early settlers made most of what they needed themselves, Shorb stocked leather, drugs, tobacco, tea, some hardware, and a small amount of fabric. With limited cash on the frontier, customers often bartered for goods with butter, eggs, potatoes, and apples. Gen. George Stidger opened Canton's first hotel at 209 West Tuscarawas Street (where the St. Francis later stood).

The Stark County Fairgrounds were an important focal point of activities in the rural community during the 19th century. The first county fair took place at Public Square in downtown Canton in 1850, making it one of the oldest annual events in the region. The county fair alternated between Canton and Massillon before the current fairgrounds was built in 1894.

During the Great Depression in the 1930s, Canton enjoyed a cultural renaissance with the development of many arts organizations we still cherish today—the Players' Guild, the Canton Symphony Orchestra, and the Canton Art Institute (now the Canton Museum of Art.) People may have had less money, but they did have more leisure time to enjoy community performances and shows.

Though many favorites from the 20th century—like Meyers Lake, the Moonlight Ballroom, and Mother Gooseland—are now gone, the memories live on.

One

AMUSEMENT PARKS

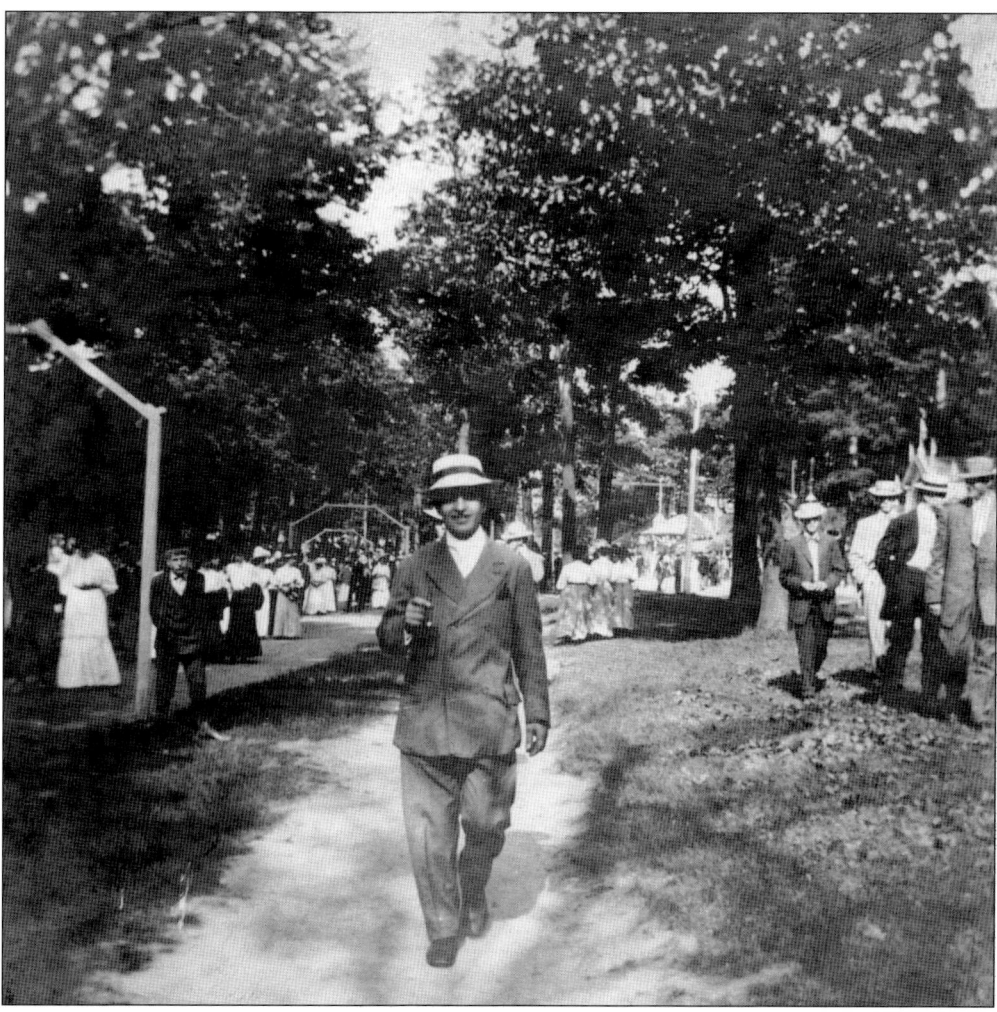

A favorite pastime for decades was a lazy afternoon at Meyers Lake, the crown jewel of Canton. The lake and the amusement park built on its shores were named for Andrew Meyer, who acquired it in 1817 as reparations for his help during the War of 1812. Meyers Lake was originally known as Lake View Park. Visitors enjoyed rides, games, and concessions, but it was also a popular spot for camping, swimming, boating, and walking the promenade, like this gentleman in 1905.

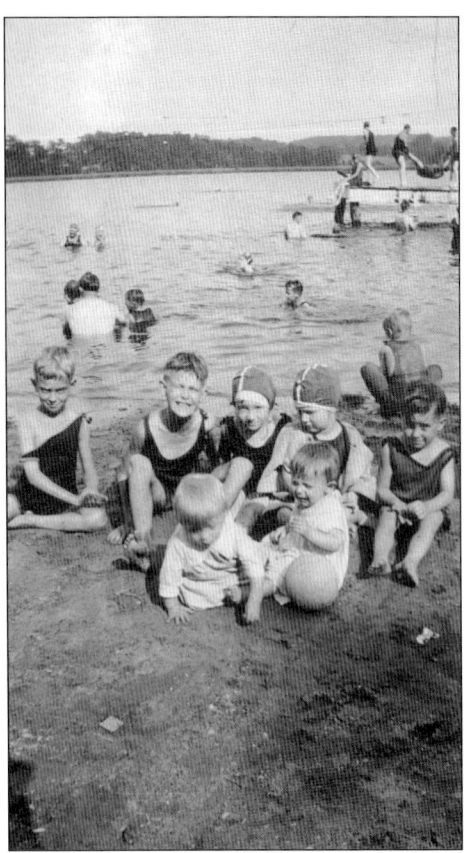

Meyers Lake is a 140-acre natural, spring-fed lake. Arrowheads, spear points, and other artifacts indicate the presence of Native American groups in the region centuries before the pioneers settled there. Swimming during the hot summer months was likely just as popular then as it was in the early 20th century for these little bathers.

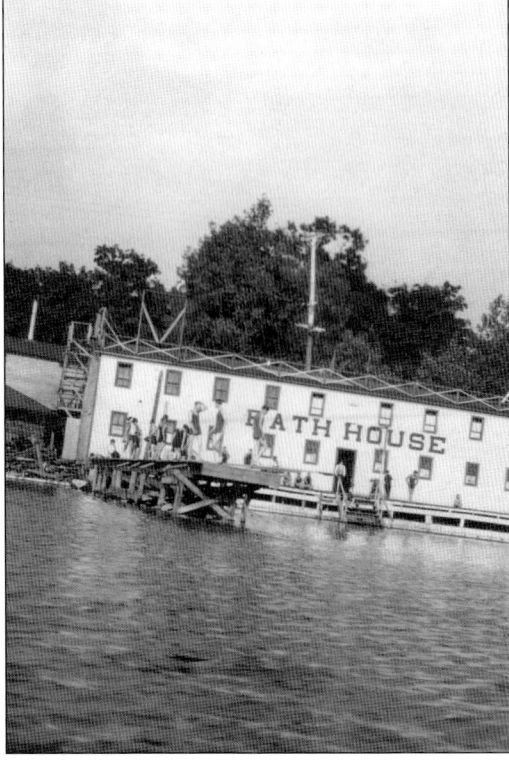

This photograph of the Meyers Lake Bath House was taken from a boat in the 1920s. At the time, men's bathing suits were one piece and usually made of wool. The Bath House featured a set of steps in front of the center door that went right into the water. A slide is just outside the photograph, to the right.

If one did not want to get wet, boating was an ideal option to enjoy the lake. The first organized activity at Meyers Lake was the Eclipse Boat Club, founded in 1869. A boathouse was constructed on the north shore of the lake in 1873, and the Canton Canoe Club was organized in 1910 and held regular regattas. Later, speedboat racing and water-skiing shows would become popular.

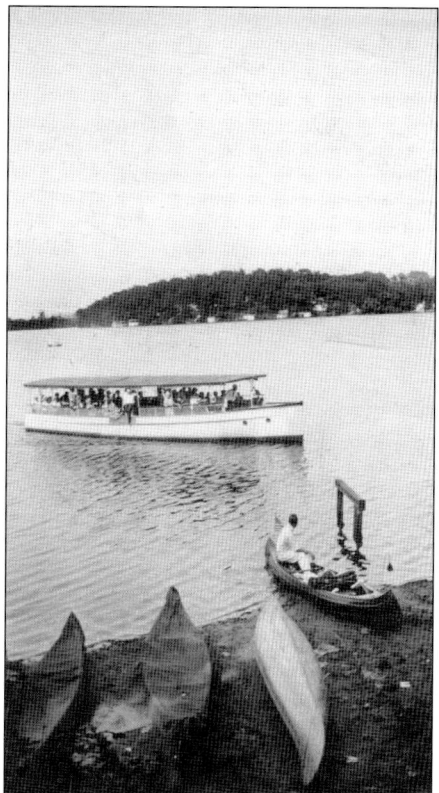

After the Civil War, increasing leisure time led to an interest in recreational facilities where people could escape from the city. By the 1890s, it was common for entire families to move out to Meyers Lake for the summer, living in tents or simple shacks that would be transformed into cottages in later years.

By 1886, several attractions had been built to entertain guests. Among them were a roller-coaster, roller-skating rink, tenpin alleys, dance floors, billiard and pool tables, boats, steam yachts, picnic grounds, a half-mile horse and bicycle track, the Canton Gun Club shooting range, and ball fields, as well as many games and concession booths.

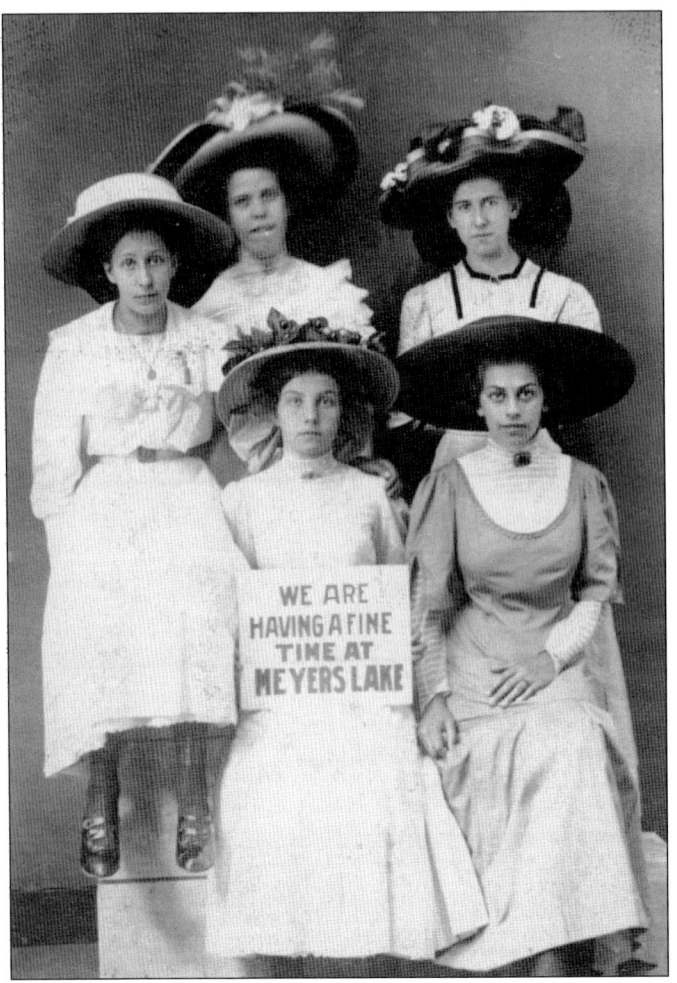

A visit to Meyers Lake was not complete without a stop at Edgell's Photo Booth. The proprietor had several signs for patrons to use in their photograph souvenirs, including "How We Look at Meyers Lake," "Not Married," "Girl Wanted," and "We Are Having a Fine Time at Meyers Lake," as seen here. The souvenirs were printed on postcards to share with friends and family near and far.

This rare photograph by W.W. King shows the boardwalk that was built at Meyers Lake over the water as part of the Lakeside Country Club. A few postcards exist showing an artist's aerial view of the bridge (though it was not depicted in the correct location), but not many photographs of it survive. The bridge was built with an arch to allow boats to pass underneath. (Courtesy of Dick Fulton.)

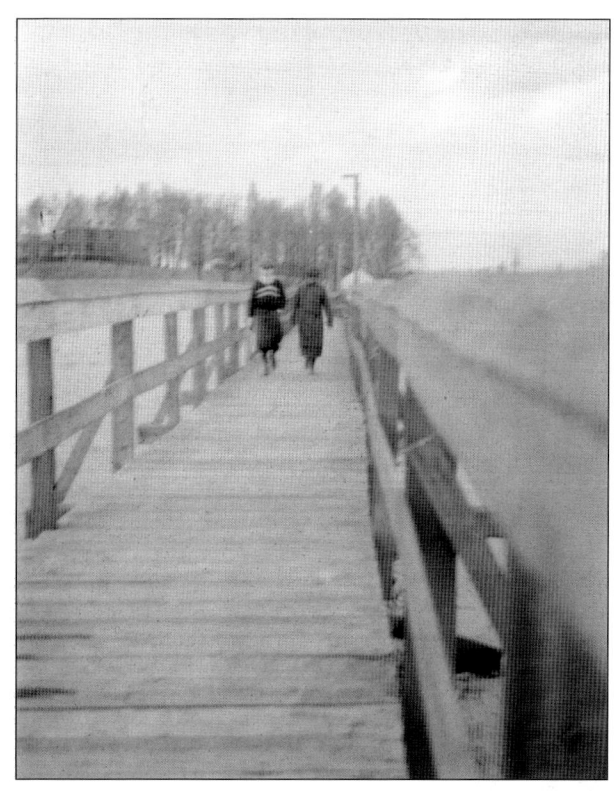

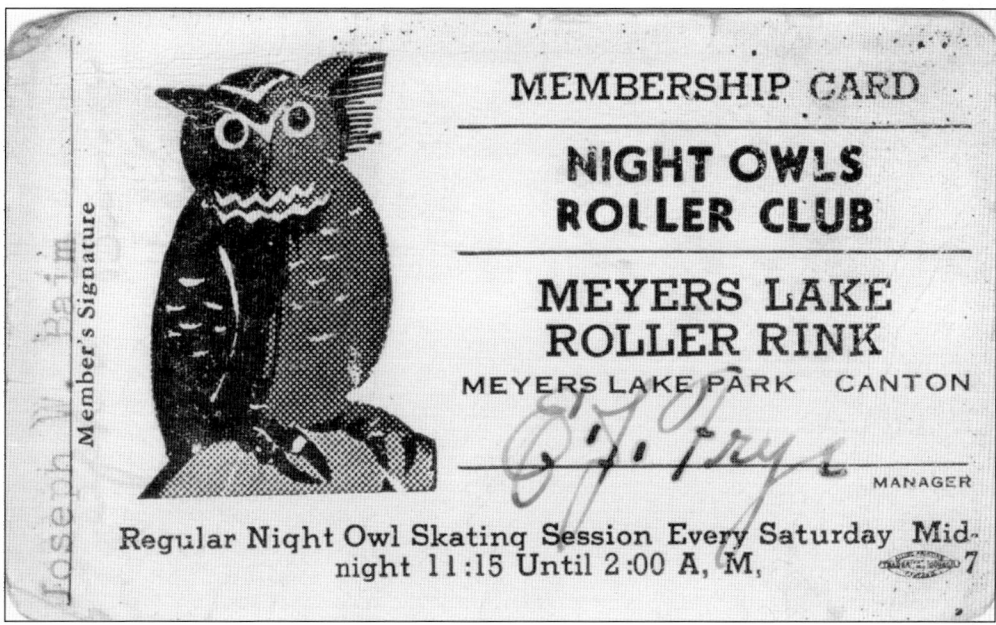

This membership card allowed the bearer to attend late-night roller-skating sessions at the Meyers Lake Roller Rink. The first roller rink was originally the Dance Hall for the park, but it was converted for skating after the Moonlight Ballroom opened in 1924. The old roller rink burned down in 1936. Its replacement opened in February 1938, but just over a year later it was also destroyed by fire. (Courtesy of the Canton Classic Car Museum.)

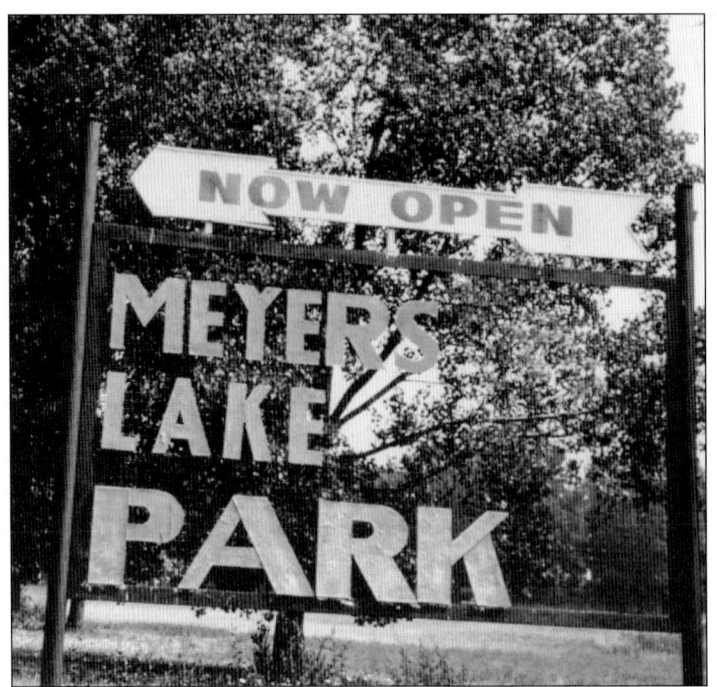

Meyers Lake Park was owned by the Northern Ohio Traction & Light Company from 1902 to 1926. Sometime after the Sinclair family purchased the park in 1926, they put up the familiar sign shown here. At the end of their first season, the Sinclairs rebuilt the entire park. They demolished many of the old buildings and rides and put up new ones, including Bluebeard's Castle near the entrance, the Tilt-a-Whirl, dodgem cars, and a modern Ferris wheel. The "new" Meyers Lake opened on May 21, 1927. (Courtesy of Dawn Walter.)

In the 1930s, Laffing Sal (also known as "Beulah the Laffing Lady") came to Meyers Lake. She was made by the Old King Cole Company in Louisville, Ohio, and stood at the entrance to the Laff-in-the-Dark ride. Many residents of Canton recall stealing a kiss or two on that ride as Laffing Sal cackled nonstop. According to local legend, the manufacturer took a retired opera singer out on the town, got her drunk, and told her "off-color" jokes until she was in hysterics. They secretly recorded her laughter and used it to animate the Laffing Lady. She has been on display in the *Stark County Story* exhibit at the McKinley Presidential Library & Museum since 2009.

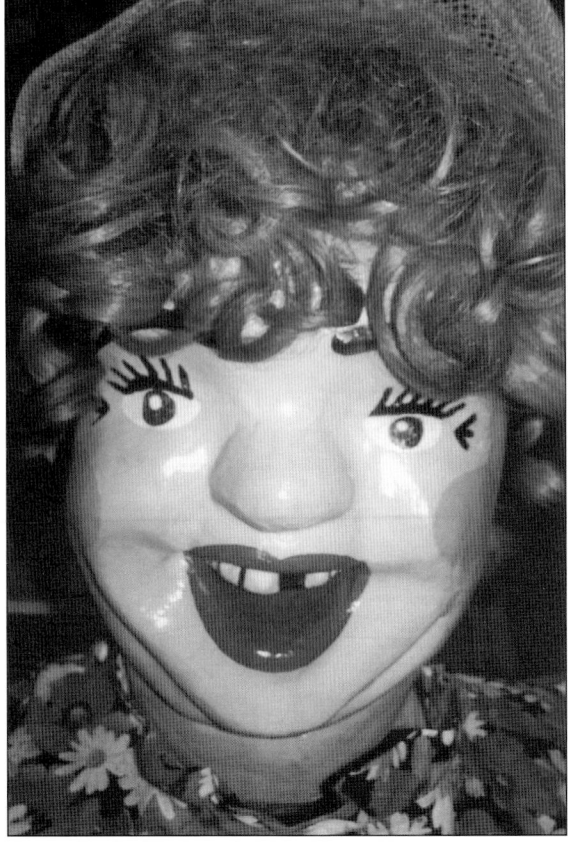

Kiddie Land, featuring rides specially designed for children, was a popular family attraction in the 1950s and 1960s. Favorites included a miniature train ride called the Meyers Lake Limited, a car ride, a cart ride, airplanes, and the boat ride shown here. An obstacle golf course also provided plenty of family fun. (Courtesy of Dawn Walter.)

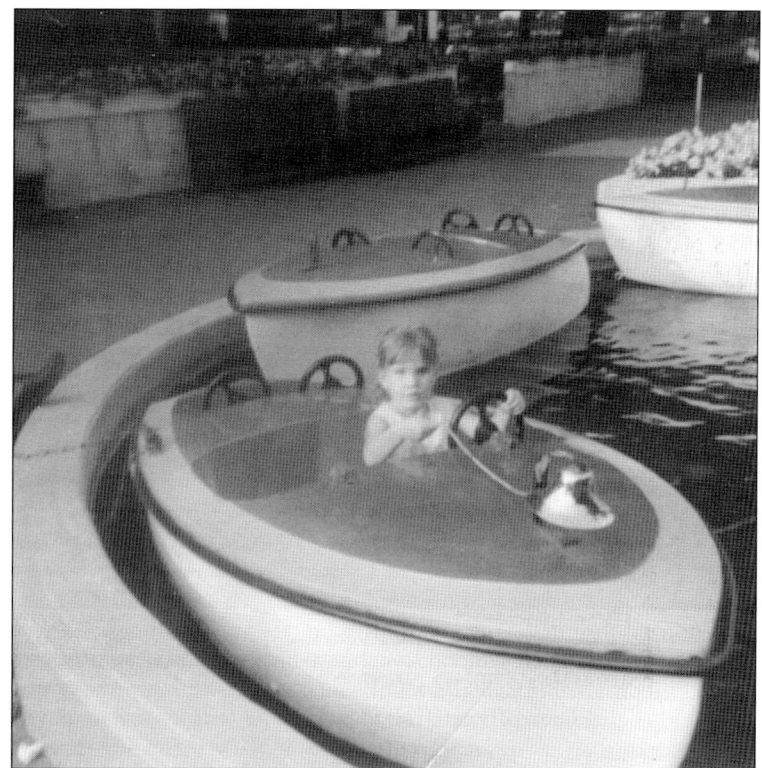

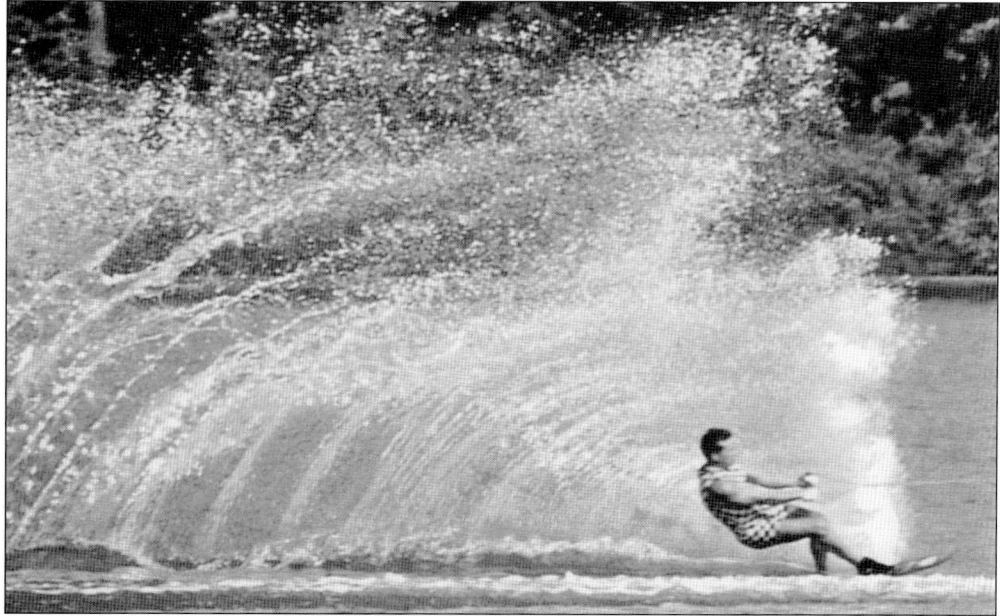

In the 1950s and 1960s, the Meyers Lake Water Ski Club drew large crowds for summer shows on Sunday afternoons. In 1963, the club hosted a three-day show featuring four events: jumping, trick, slalom, and barefoot skiing. The National Water Ski championships took place at Meyers Lake in August 1968, and more than 100,000 people came to watch the skiers compete. (Courtesy of Al Longbrake.)

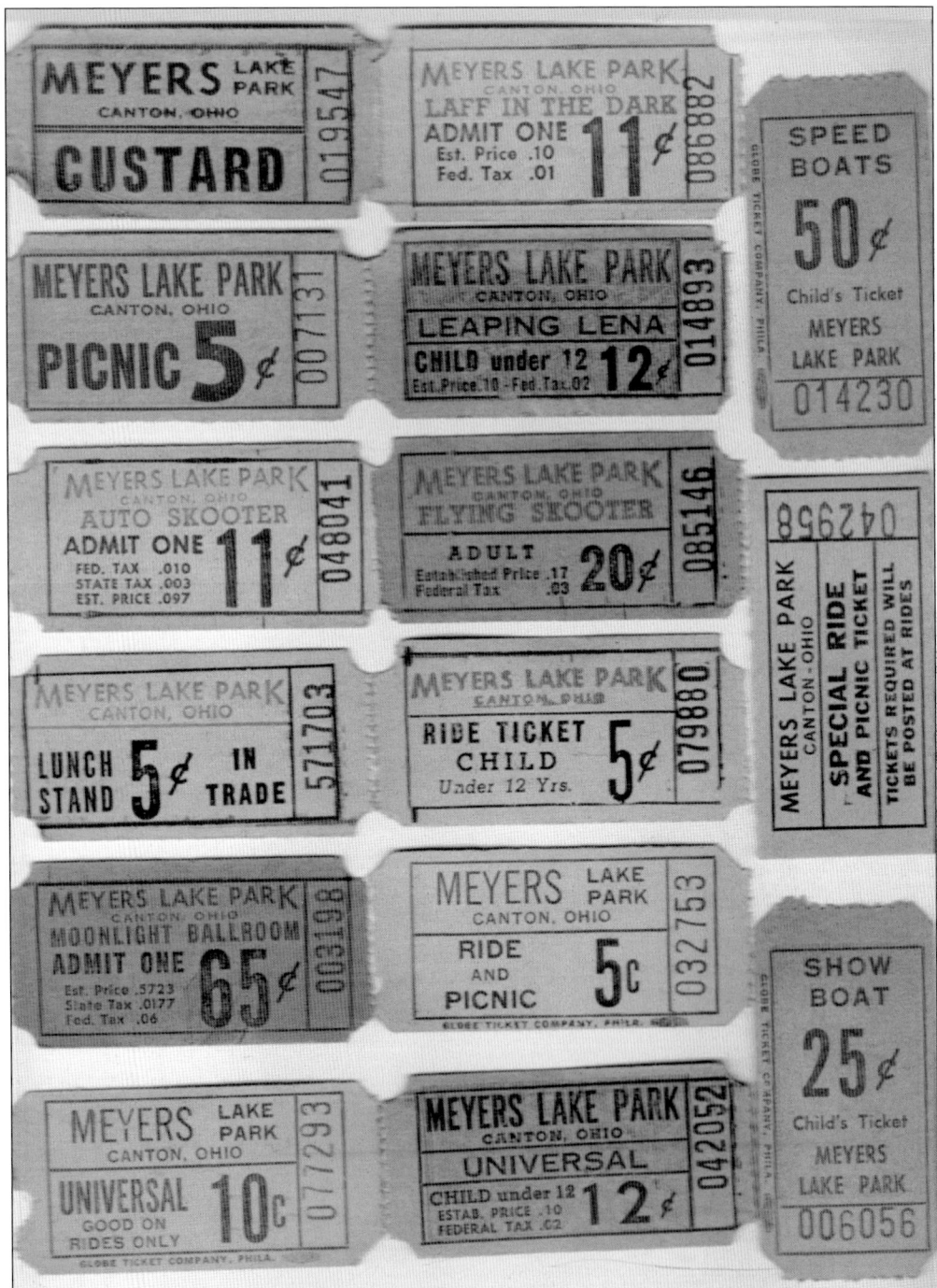

In later years, each ride and attraction had its own unique ticket with a different price. Dawn Walter has collected several tickets, including examples from the Moonlight Ballroom; picnics; the famous custard stand; and rides such as the Laff in the Dark, Auto Skooter, and speedboats. Other favorite rides included a roller-coaster called the Comet, the Bug, the Calypso, and the Carousel, which still operates today in Hartford, Connecticut. (Courtesy of Dawn Walter.)

Meyers Lake Park ran regular advertisements in the *Repository* to let people know what was coming up at the park and the Moonlight Ballroom. This advertisement publicized the start of daily hours for the summer as well as the Tommy Dorsey Orchestra coming to town. Some school districts provided tickets in report cards on the last day of school to be used during summer vacation. (Courtesy of Linda Todd.)

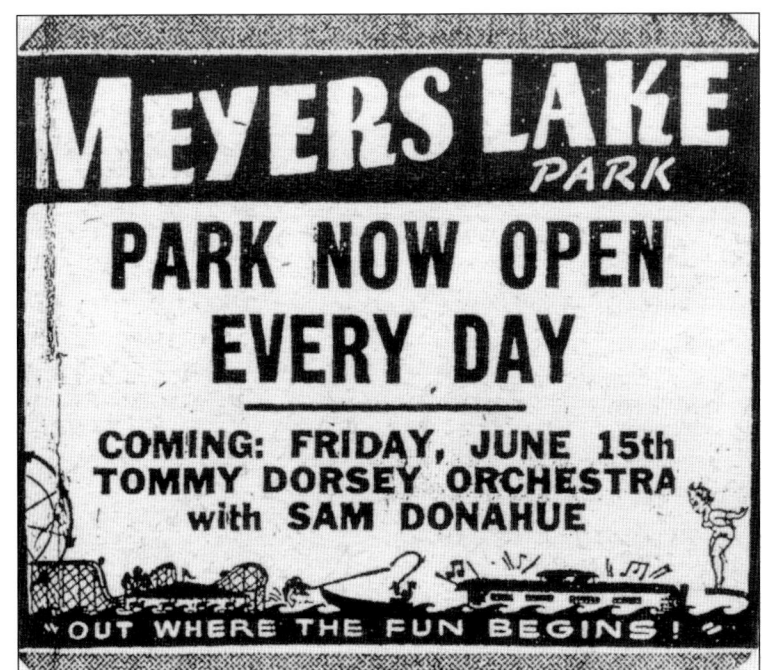

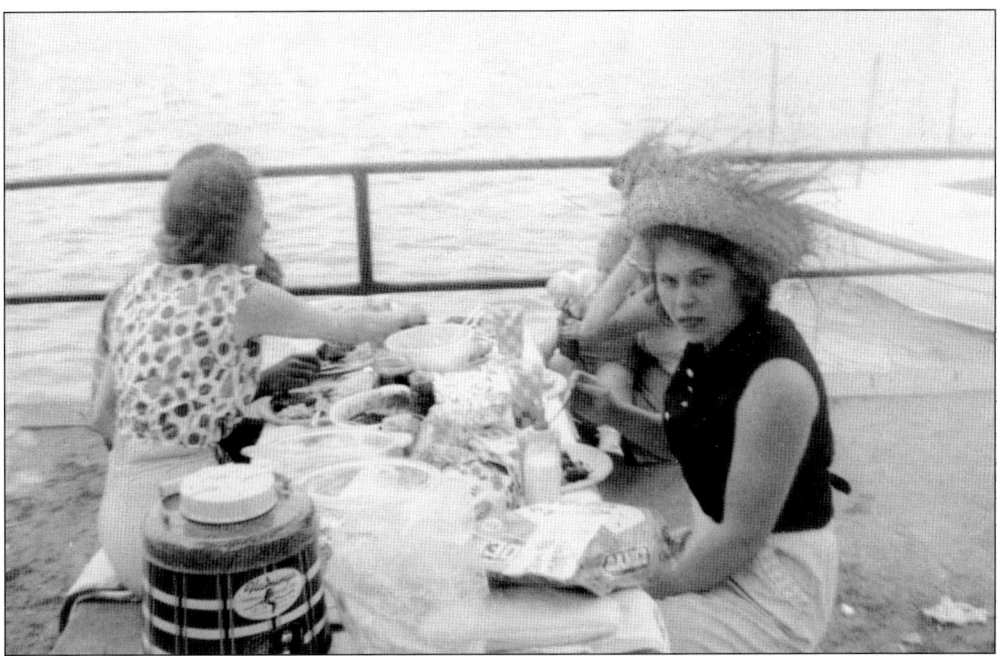

Meyers Lake was a perfect backdrop for a family picnic, like this one enjoyed by Gen Hiuley and Linda Day in 1961. Company picnics were also popular, attracting crowds of up to 20,000 from just one business such as the Hoover Company or the Timken Company. Businesses and unions throughout Northeast Ohio hosted company picnics during the park's heyday in the mid-20th century. As companies began to cut back on perks like picnics in the 1960s and 1970s, Meyers Lake lost a significant revenue stream. (Courtesy of Linda Todd.)

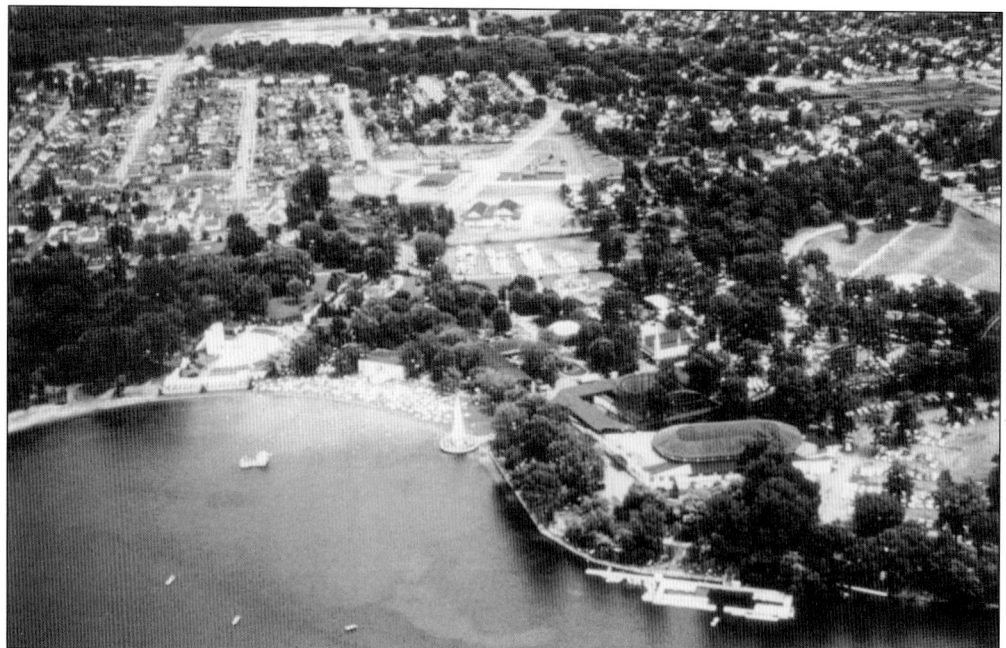

With the rise of supersized amusement parks like Cedar Point, attendance started to drop off at Meyers Lake in the 1960s. The Sinclair family decided to call it quits after almost half a century of running the park, and the Canton landmark closed its gates for the last time after the 1974 season. (Courtesy of Jim McVay.)

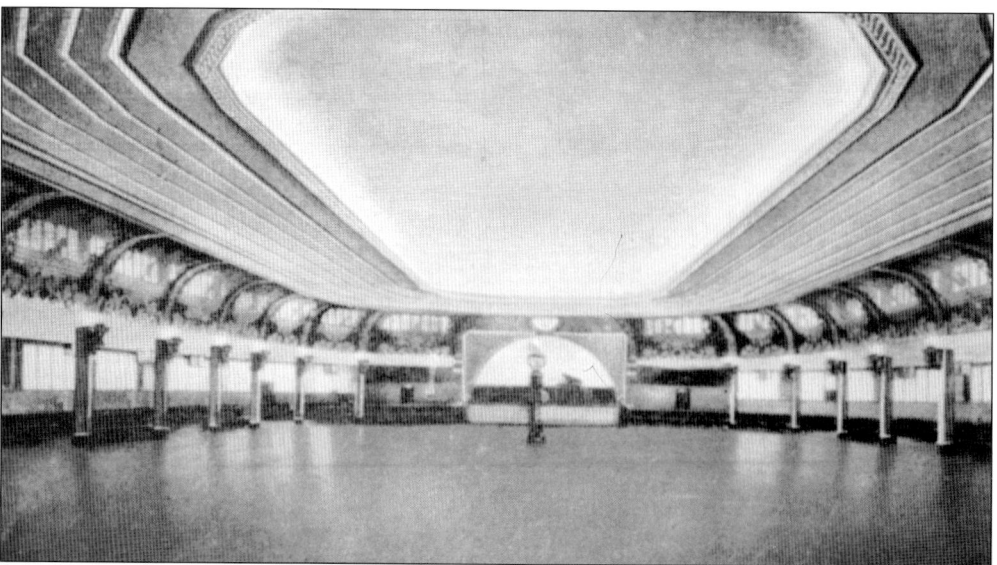

The Moonlight Ballroom was built as an open-air dance hall in 1924. At 36,000 square feet, it was the largest open-air dance pavilion in the state. Since Ohio's climate is not conducive to year-round dancing outdoors, a roof was added over the winter of 1926 to 1927. The Moonlight Ballroom attracted some of the biggest performers in show business, and people came from all over Northeast Ohio to dance to the music of Guy Lombardo, Benny Goodman, Tommy Dorsey, and many others. The Moonlight Ballroom was also the site of company dances, high school proms, first dates, and lots of marriage proposals. (Courtesy of Jim McVay.)

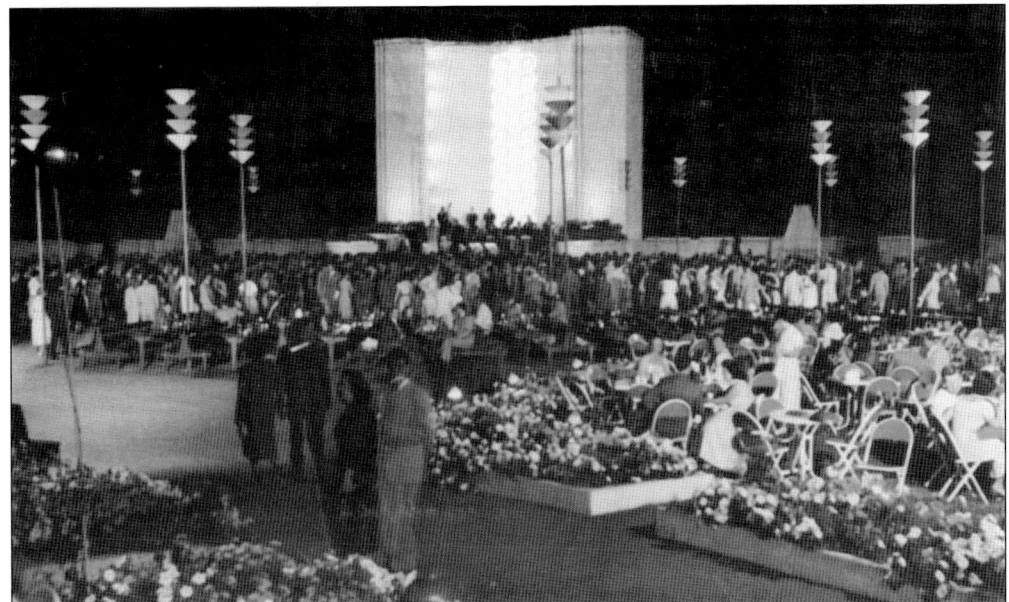

The Moonlight Gardens, an open-air dance hall, opened at Meyers Lake in 1942, and summer dances were held there under the stars. Among the Moonlight Gardens' most spectacular features were the 10,000 petunias planted nearby. To this day, the scent of petunias sparks wonderful memories for those who spent their youth at the Moonlight Gardens. During the season, it was open for dancing on Sunday, Tuesday, and Saturday nights. (Courtesy of Linda Todd.)

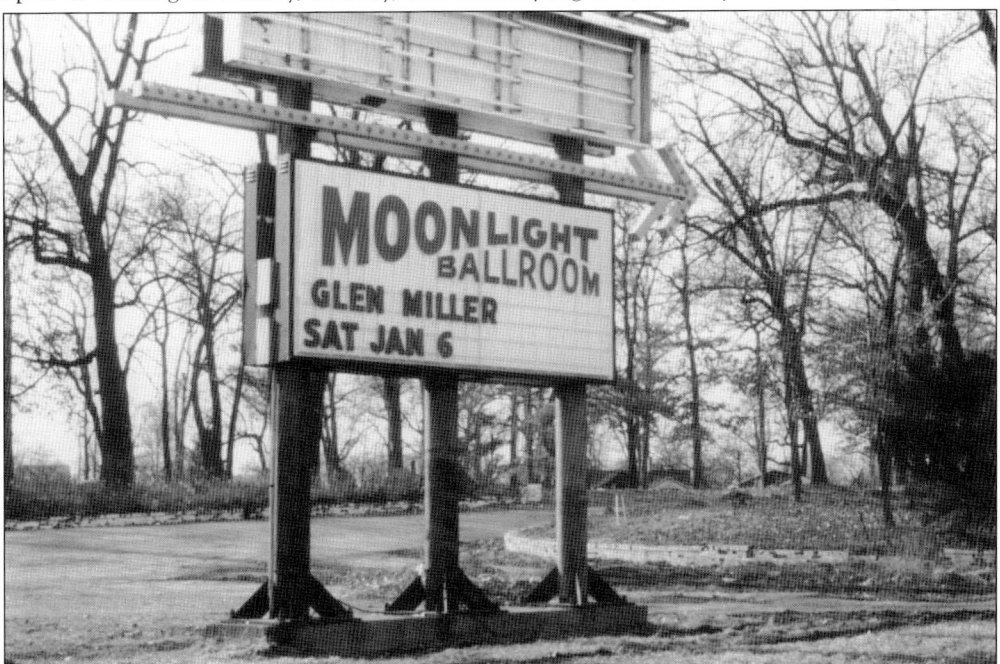

After the amusement park closed in 1972, the Moonlight Ballroom was also on the verge of closing. A Massillon realtor bought it for $300,000 in 1977. After extensive remodeling, it reopened the following summer. The largest crowd since the reopening came to see the Glenn Miller Orchestra on January 6, 1979. (Courtesy of Jim McVay.)

That night, a massive fire completely destroyed the Moonlight Ballroom. Since then, no one has tried to bring back the magical summer days of Meyers Lake. The abandoned rides and concessions have long since been torn down, and no sign of the popular amusement park exists today. (Courtesy of Jim McVay.)

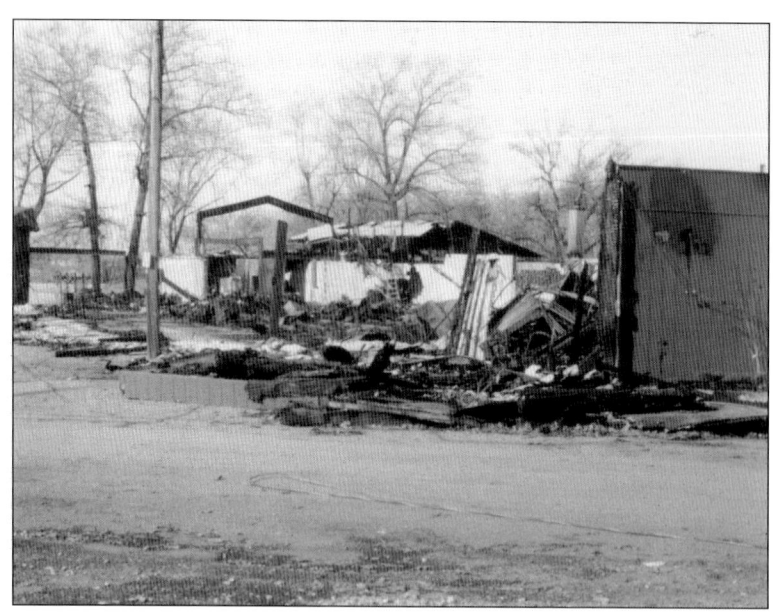

Agnes Dodd Frank first presented the idea for a children's park in 1954, based on a kiddie zoo in her hometown of Pittsburgh, Pennsylvania. The site that would become Mother Gooseland was originally known as Dueber Park, located between West Tuscarawas Street and Sixth Street SW, just south of Waterworks Park. It was within walking distance for many of Canton's children, and it was also along the bus route. The Canton Junior Chamber of Commerce, or Jaycees, adopted the idea as their community-service project, with Dr. Harry Guist serving as chairman.

Fundraising began in 1956 when the Jaycees sold "deeds" for tiny parcels of land for 50¢ each. Each donor received a certificate with their contribution. The Jaycees set up many events to sell their deeds, including an Easter Egg Hunt, a family fun day in downtown Canton, and a booth at the Stark County Fair. (Courtesy of Linda Todd.)

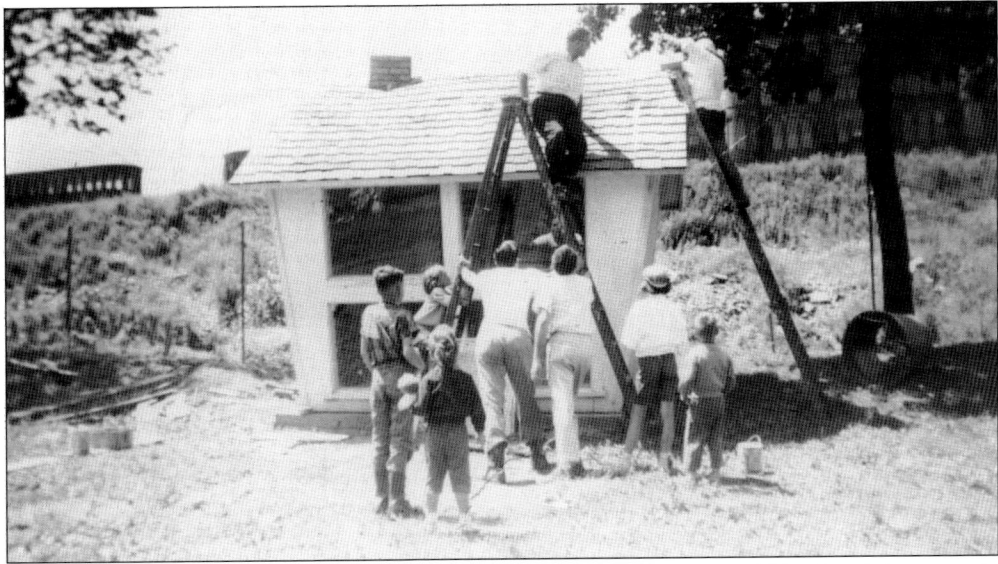

Canton architects Cox & Forsythe drew up plans for the park. There would be 30 exhibits, mostly based on elements from children's stories like *Jack and the Beanstalk*, *The Old Woman Who Lived in a Shoe*, *Ali Baba and the 40 Thieves*, and *Humpty Dumpty*. The Three Bears' House, shown here, was a miniature two-story home that was sponsored and decorated by the Jaycees Auxiliary.

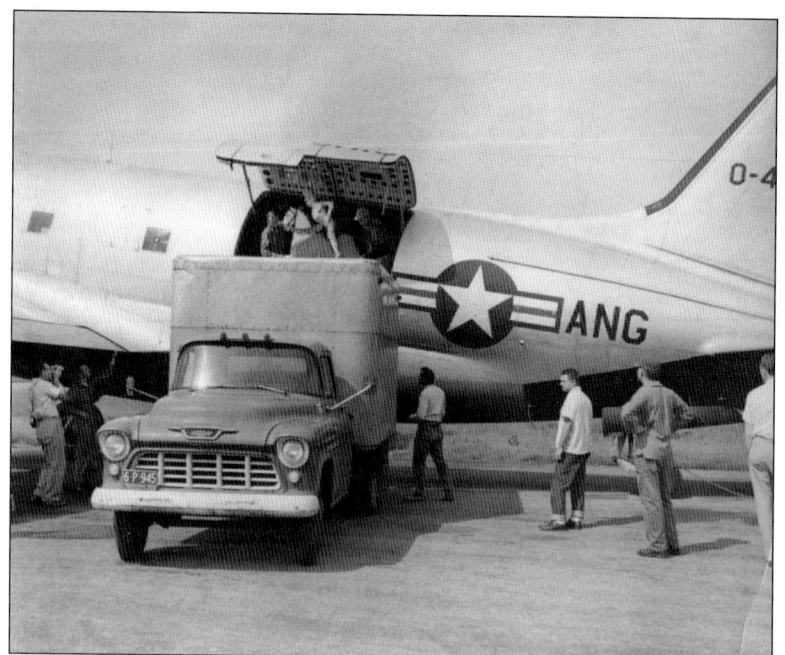

Most of the original 20 figures were made by B.B. Bradley in Tampa, Florida, who charged only for the materials and donated the labor. The Ohio Air National Guard delivered the figures to Canton during a routine training flight to Florida. This photograph shows one of the knights for the Humpty Dumpty exhibit being carefully unloaded from the plane.

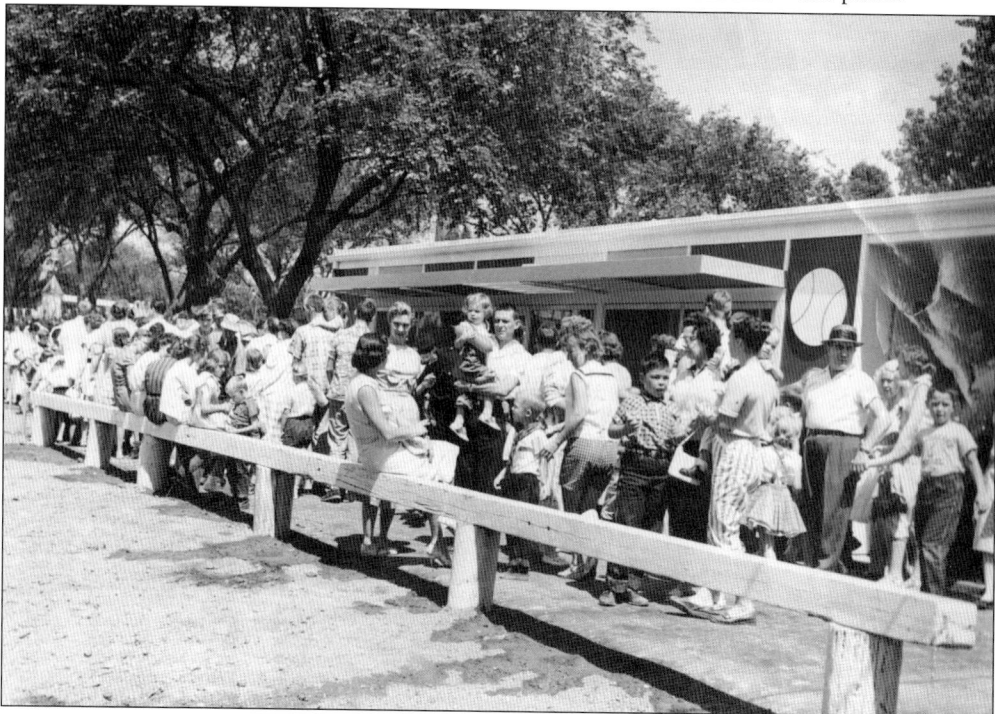

Opening day finally arrived on August 23, 1958. The festivities began with a 20-unit parade featuring children's television personality Wilbur Whiffenpoof, a calliope, Scout troops, Army trucks, Marine tanks, marching bands, pony carts, and open cars with dignitaries who had helped to make the children's park a reality. More than 9,000 people visited Mother Gooseland on opening day. With the grand opening complete, the Jaycees handed over the keys to the City of Canton Parks Department, who would take charge of operations.

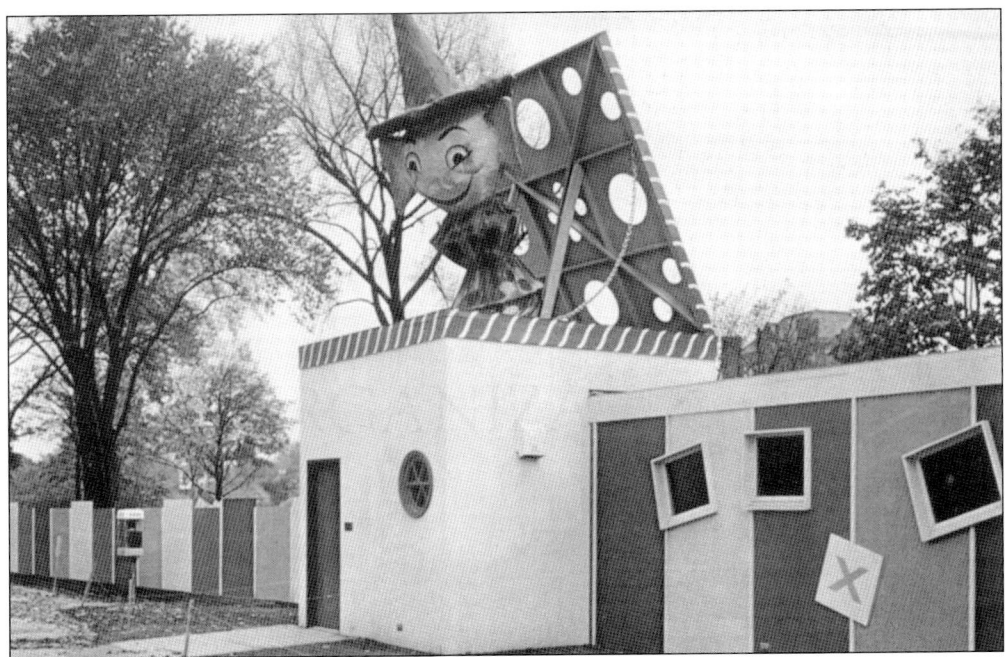

The administration building, with a colorful jack-in-the-box on its roof, was made possible by a $15,000 grant from the Timken Foundation. The refreshment stand inside the building featured a floor behind the counter that was two feet lower than ground level. When kids walked up to place their order for popcorn, ice cream, or candy, they were standing at eye level with the adult who was serving them. (Courtesy of Becky Lloyd.)

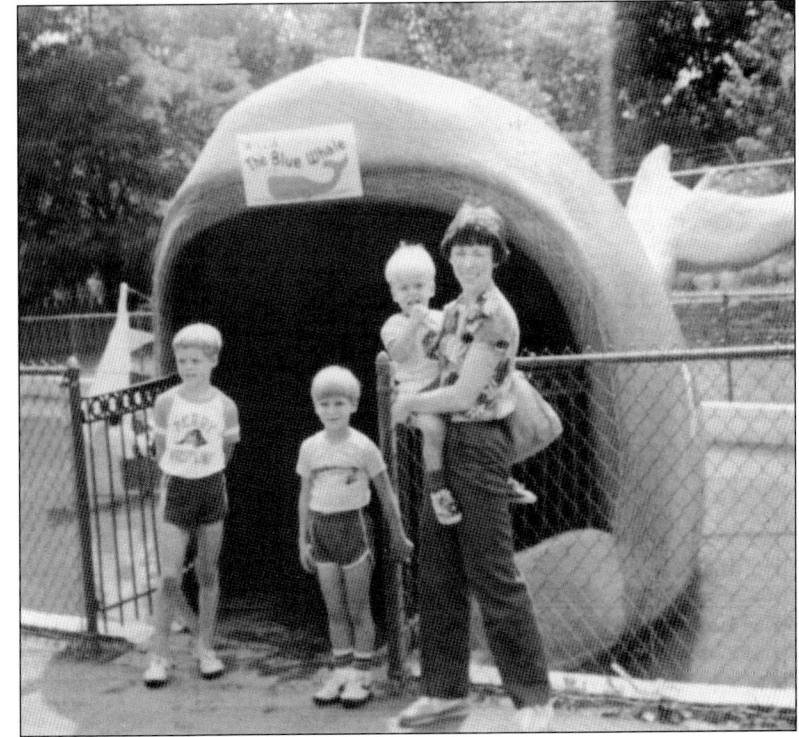

A favorite exhibit was Willie the Whale, constructed by volunteer workers from the Lathing & Plastering Contractors Association of Canton and Massillon. At 21 feet long, 9 feet high, and 9 feet wide, he weighed a whopping 14,000 pounds. Designers created a lagoon around him by damming the Nimishillen Creek. (Courtesy of Joyce Bair.)

The New York, Chicago & St. Louis Railroad Company donated a 75-ton retired steam locomotive and a 36-ton tender, which was installed on 78 feet of track. The locomotive was built at the Wheeling & Lake Erie shops in nearby Brewster, Ohio, in 1935 and traveled one million miles while it was in service. According to an article in the *Repository* in June 1958, the six-wheel switcher was placed in Mother Gooseland "as a memorial to the great steam vehicles which had such a big role in the growth of the United States." (Courtesy of Linda Todd.)

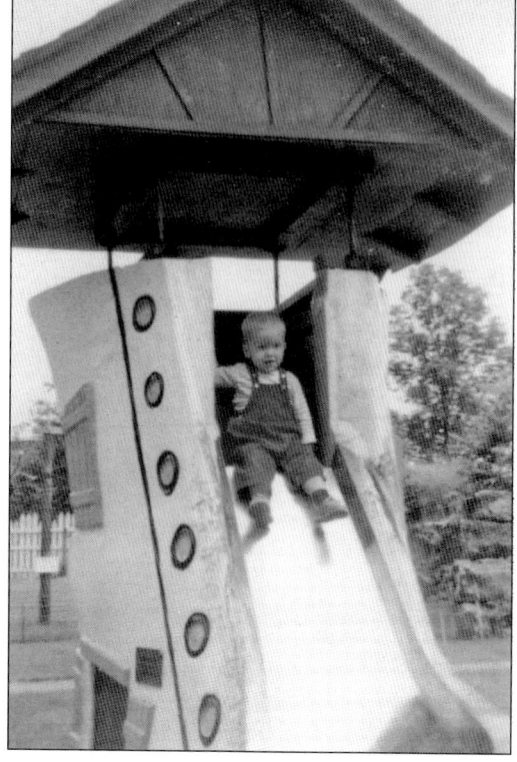

Robbie Ruegg slides down the Old Woman Who Lived in a Shoe exhibit in the late 1960s. In addition to donated labor and supplies, it cost $75,000 in cash to build Mother Gooseland. Local business donors included Shullo Construction Company of Akron; Metropolitan Brick, Inc.; the Structural Clay Products Institute and Bricklayers Local; Stark County Home Builders Association; Sugardale Provision Company; Diebold, Inc.; and many others. (Courtesy of Linda Herald.)

Laura E. Diamond and Jessica Morris, both two years old, enjoy the turtle at the Mother Gooseland playground in July 1986. Throughout the 1960s, Mother Gooseland enjoyed 50,000 visitors a year. It was staffed by part-time summer workers from the parks department. With admission at just 25¢ for adults and 10¢ for children, the park was an affordable and safe place for kids to play. (Courtesy of Rosemary Diamond.)

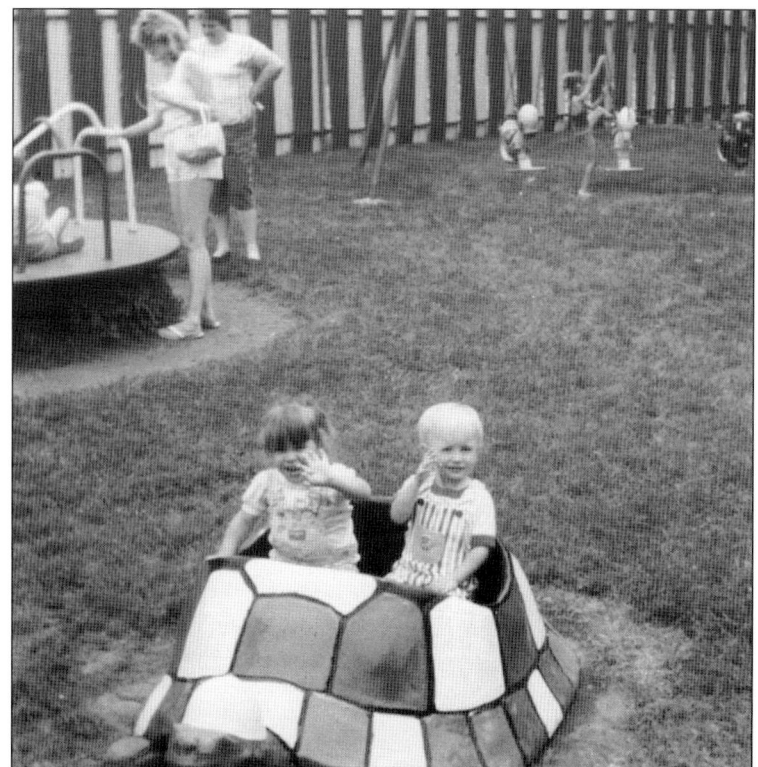

Charles Curtis celebrated his fourth birthday with a ride on the merry-go-round. Over the years, Mother Gooseland opened new attractions, such as a US Air Force jet trainer, a 1922 fire truck, and live animals including seals, goats, a horse and colt, peacocks, and rabbits. Kiddie rides became a favorite part of the park in later years. (Courtesy of Wanda Tull.)

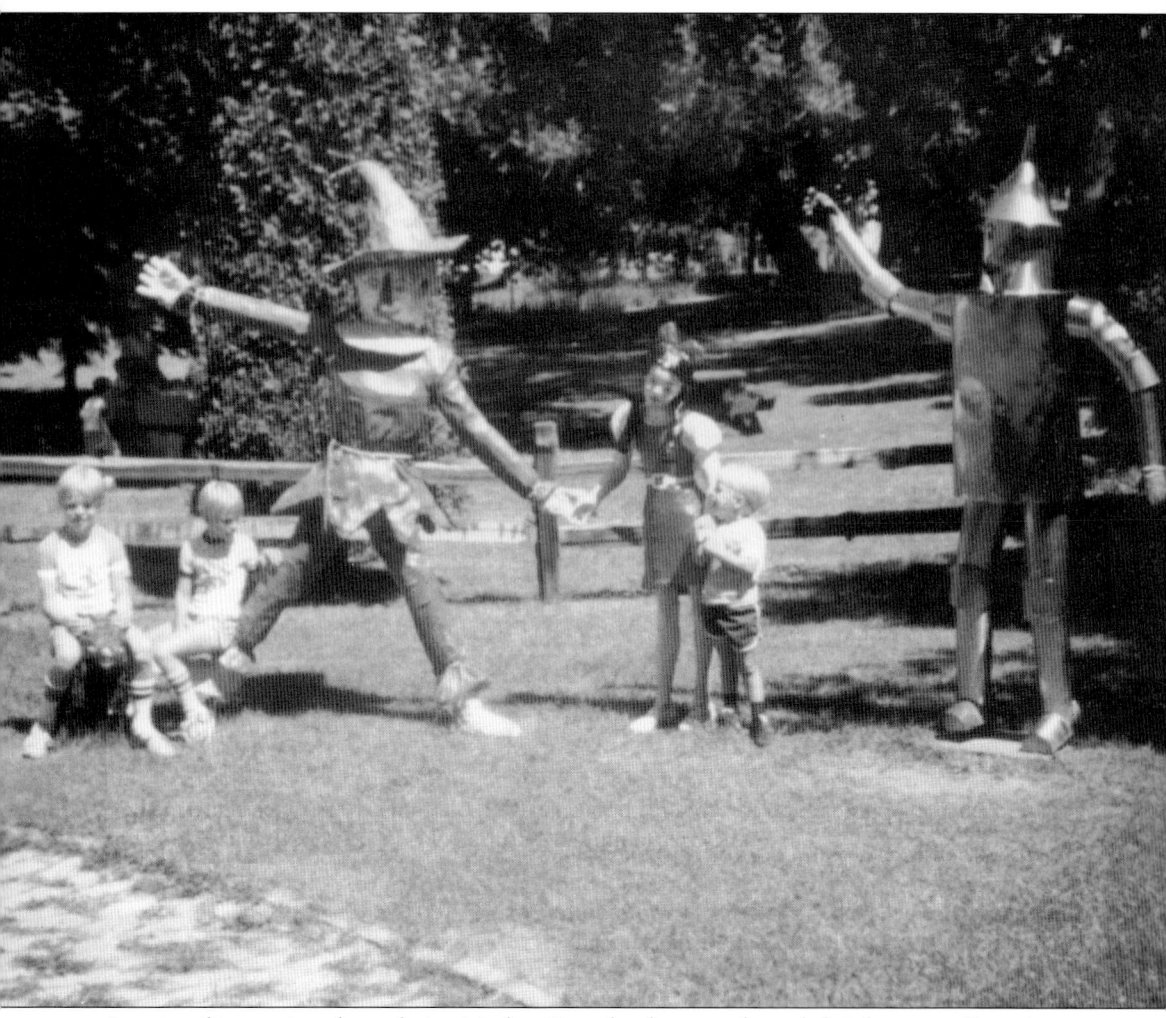

In spite of its continued popularity, Mother Gooseland operated at a deficit for most of its existence. In the summer of 1981, the city decided not to open the park for the first time. Mothers and children picketed city hall in an unprecedented show of support for the park, and city council voted to spend $25,000 from a recently approved city income tax to refurbish it. It reopened the next summer, but before long, lack of funds became a problem again. Mother Gooseland closed in 1989. Many of the figures, including the *Wizard of Oz* figures shown here, found a new home at Sluggers & Putters in Canal Fulton. All that remains of Mother Gooseland today is Willie the Whale, who is too big and too heavy to be moved to another location. (Courtesy of Joyce Bair.)

Two

CIRCUSES, CELEBRATIONS, FAIRS, AND MORE

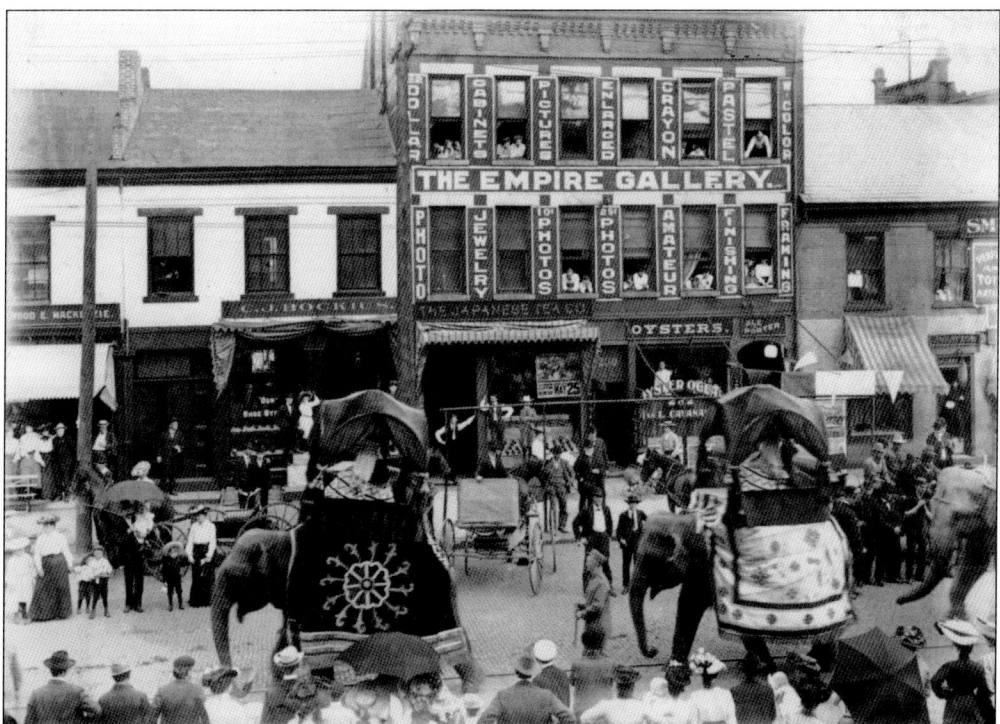

The Barnum & Bailey Circus came to Canton many times over the years. During William McKinley's Front Porch Campaign in October 1896, Barnum & Bailey altered its normal parade route to pass by the future president's home. The circus reserved a special box at the show for McKinley's wife, Ida, and her friends to attend. Although tickets were required for the big show, the parade through town was always free. This parade took place on May 25, 1904, in the 200 block of South Market Avenue.

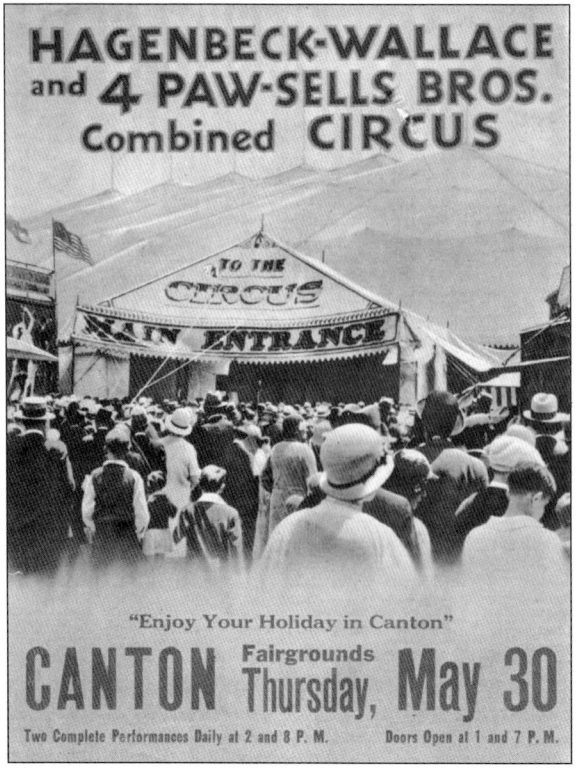

The Main Circus came to Canton on May 7, 1904, and paraded up South Market Avenue. Circus founder Walter L. Main was a native of Northeast Ohio, growing up in Geneva in Ashtabula County. His circus traveled all over the country, with winter quarters in his hometown. In 1904, the Main Circus visited Salem before Canton, and then moved on to Cleveland, Akron, and Warren.

The Hagenbeck-Wallace Circus came to the Stark County Fairgrounds in Canton in 1935. It claimed to have the longest free street parade in the world and traveled with a variety of baby animals to "delight its countless juvenile patrons." Based in Peru, Indiana, the Hagenbeck-Wallace Circus was once the second-largest circus in the country, but it folded a few years after this stop in Canton.

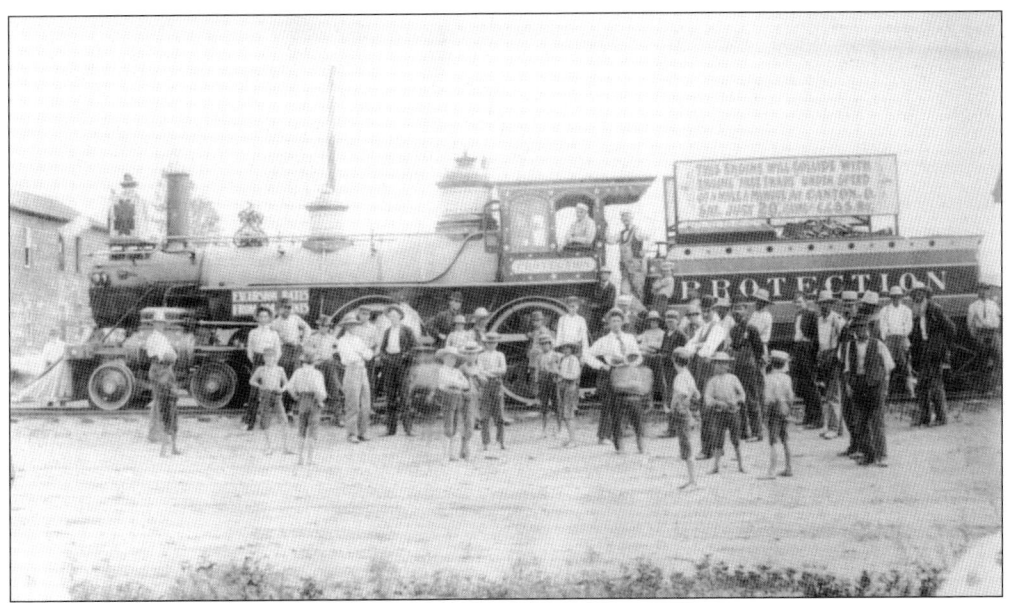

On Saturday, July 20, 1895, a train wreck spectacle between the engines *Protection* and *Free Trade* was staged in Canton. Typically, promoters sold tickets to these publicity stunts, in which two locomotives hurtled toward each other at top speed. The engineers would jump off just before the trains collided in a spectacular crash. Protectionism and free trade were buzzwords in the 1896 presidential election, suggesting this event might have been politically motivated. (Courtesy of Dick Fulton.)

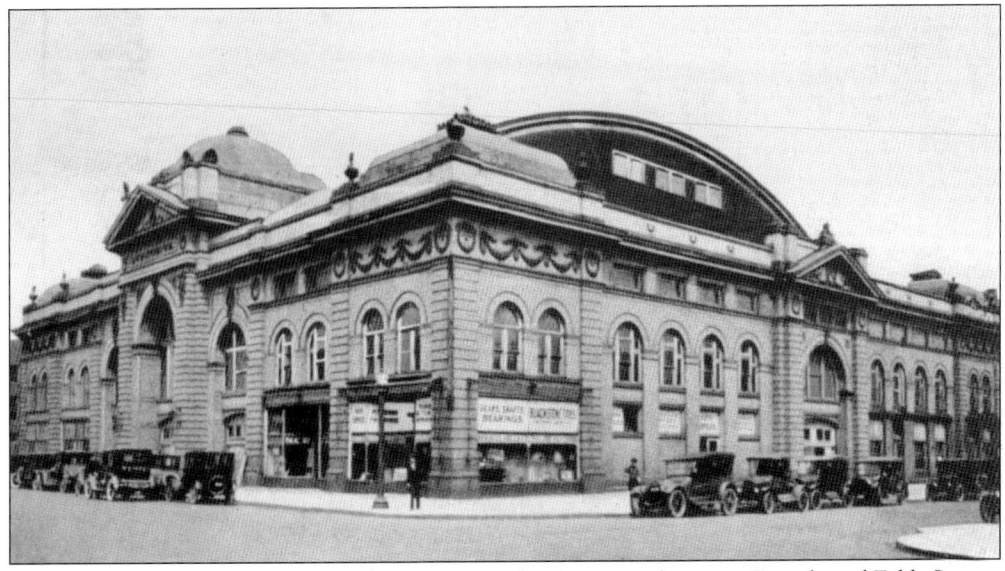

The Auditorium opened in 1904 on North Cleveland Avenue between Fourth and Fifth Streets and was the fourth-largest structure of its kind in the United States. With seating for 4,700 and nearly 2,000,000 square feet, the new venue made Canton a true convention city. Several organizations hosted events there, including the Ohio Sunday School Association, the United Spanish War Veterans of Ohio, the Ohio Department of the GAR, the Ohio Grange, and the National Association of Letter Carriers. Famous speakers included Woodrow Wilson, William Jennings Bryan, and Carrie Nation.

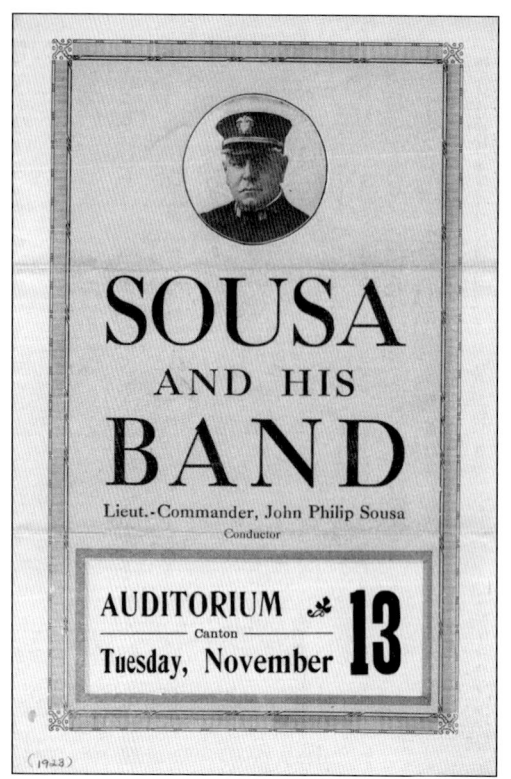

Organizers booked the best singers, musicians, orchestras, and speakers, including Sousa's Band, directed by the March King himself. Conventions, dances, and rallies were also held in the Auditorium. Famous evangelist Aimee Semple McPherson held a series of spectacular meetings in 1921, and Billy Sunday held his second big revival that continued for five weeks. The New York Philharmonic Orchestra played there, as did Enrico Caruso. The YMCA moved their lecture series to the venue, and it was the site of McKinley High School graduation exercises.

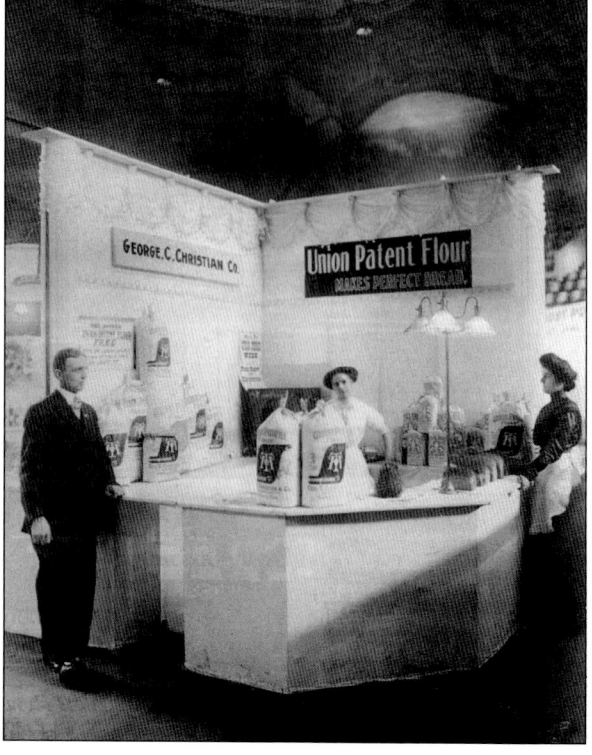

The Auditorium also hosted trade shows and expositions like this Food Show in 1918. A sign on the wall in the George C. Christian Company booth reads, "One barrel Union Patent Flour FREE to the one guessing correct number of pins in turnip." The turnip is visible on the counter.

An unidentified man and woman drive around downtown Canton with two bears in the car, advertising the hippodrome that evening at the Auditorium. The word *hippodrome* comes from the Greek word for a horse or chariot race and came to mean an arena for equestrian spectacles, a variety show, or a circus.

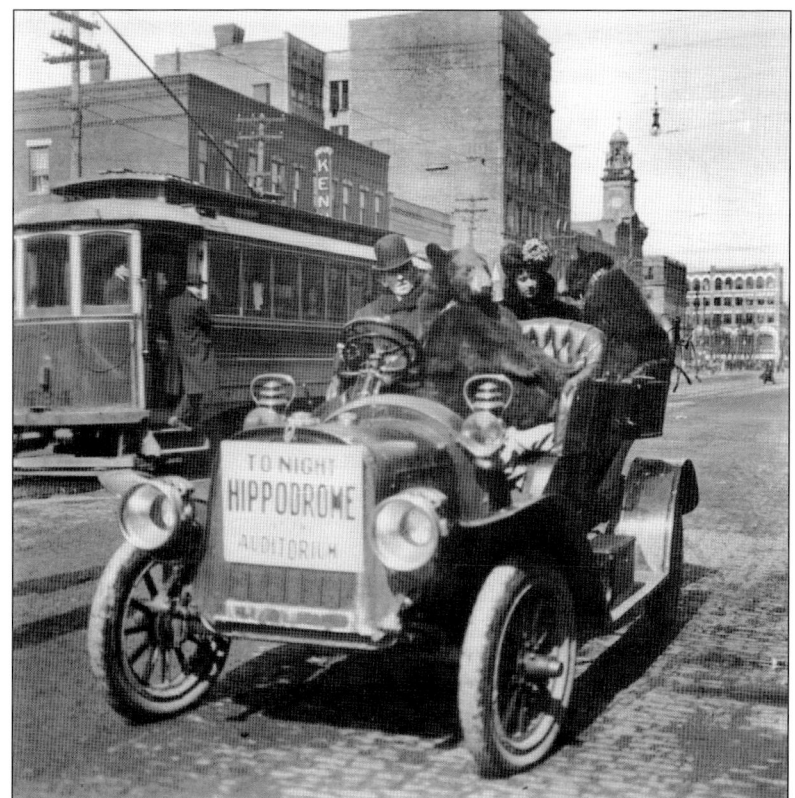

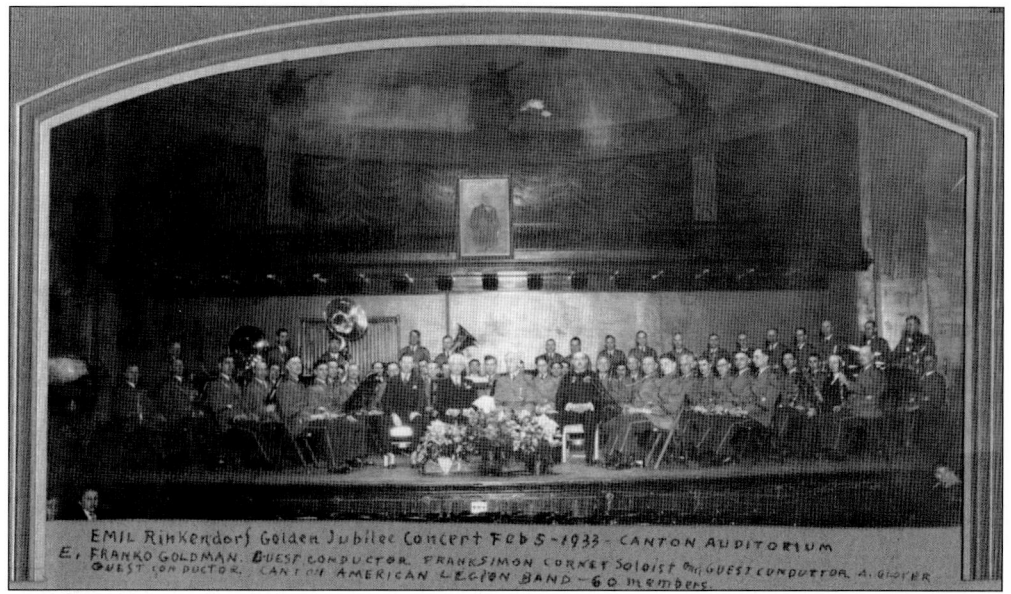

The American Legion Band performed at the Auditorium on February 5, 1933. The handwritten caption reads, "Emil Rinkendorf Golden Jubilee Concert . . . E. Franko Goldman Guest Conductor, Frank Simon Cornet Soloist and Guest Conductor, A. Glover Guest Conductor. Canton American Legion Band—60 members." A portrait of Canton's favorite son, William McKinley, hangs in the background above the stage.

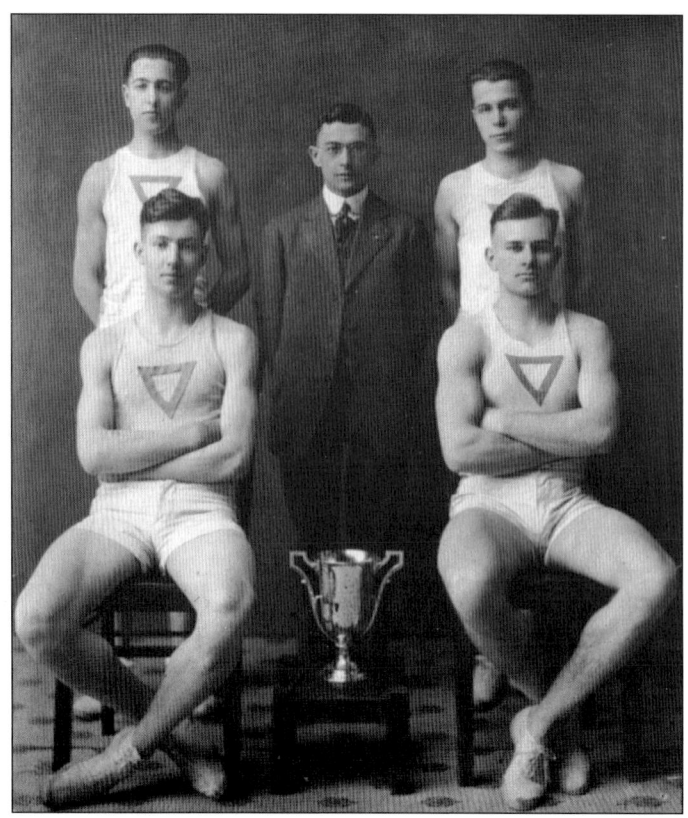

The YMCA track team, shown in this photograph, held indoor meets at the Auditorium. The professional sporting events were unsurpassed and included championship boxing events, wrestling matches, basketball games, and even roller polo on skates. The Auditorium hosted McKinley High School's home basketball games as well as several charity events and benefits.

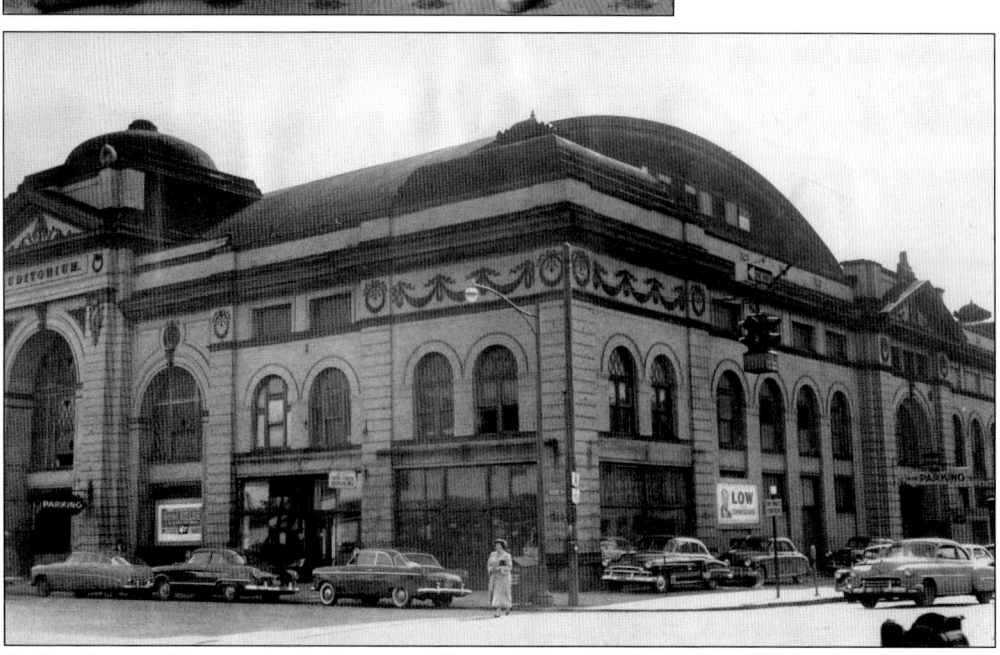

Sadly, after just 36 years, the Auditorium fell into disrepair and was closed because of fire hazards. The deputy state inspector called the building "an ideal structure for a major catastrophe" because it was mostly made of wood. It was closed for events in 1940, although some of the street-level shops continued to operate.

A major bond issue for $2.85 million worth of repairs failed to pass in 1947. After years of debate on what to do with it, the site was sold to the Cleveland Avenue Realty Company, who turned it into a parking garage, and later, a parking lot. The Auditorium last appeared in the city directory in 1956.

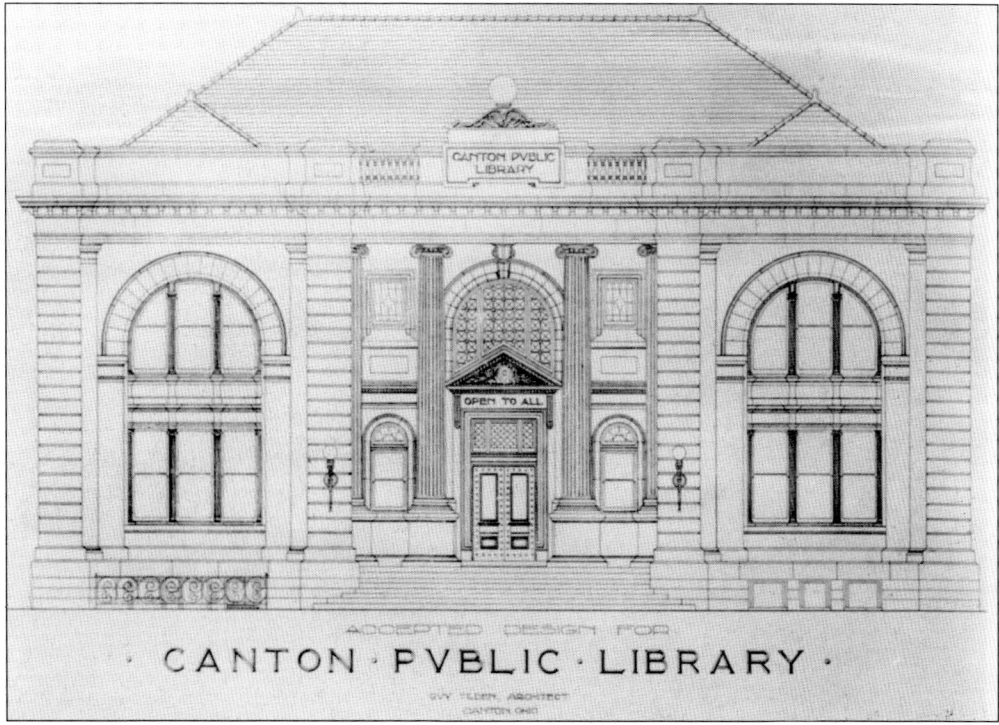

Andrew Carnegie spent $2,871,483 to build 111 public libraries in the state of Ohio alone. Recipient communities were required to provide 10 percent of the amount of Carnegie's donation annually for the salary of a librarian and upkeep of the library, and the city or town also had to provide the land for the library, since funding was for construction only. Designed by architect Guy Tilden, the Canton Public Library opened in 1905 at 236 Third Street SW. The Stark County District Library operated from that location until its new building was completed at 715 Market Avenue North in 1978. In 1982, the original Carnegie library building was listed in the National Register of Historic Places.

In 1909, the annual Labor Day festivities were combined with the Stark County Centennial celebration. More than 6,000 people participated in a grand industrial parade, which was one of the largest of its kind in the history of the state. There were nine bands from Stark County and one from Akron, plus many elaborate floats.

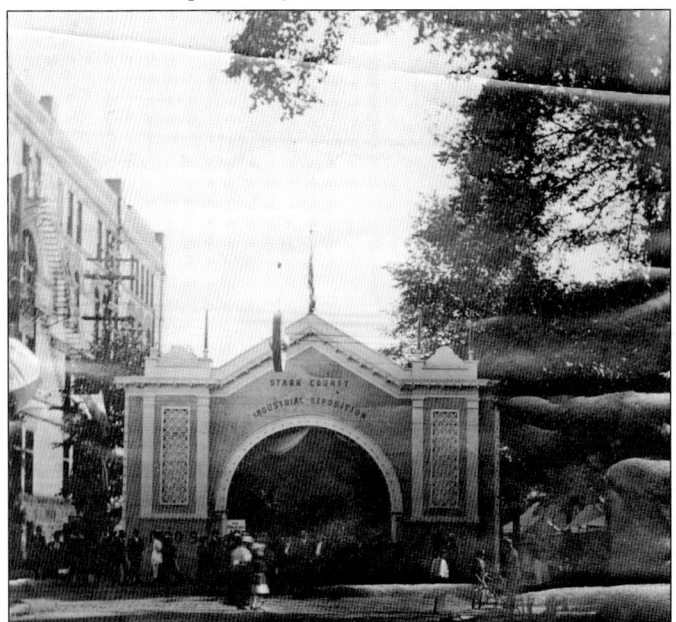

The Stark County Industrial Exposition was held September 6–11, 1909. For the combined Labor Day and centennial celebration, Charles Krichbaum gave a speech titled "The Achievements of the People of Stark County." The Aero Club staged double ascensions to provide balloon races for spectators. The *Ohio* traveled 20 miles before landing in Alliance, while *Sky Pilot* came down 35 miles away in Portage County, near Palmyra.

Canton celebrated its sesquicentennial in August 1955. The community extravaganza lasted for a week, with theme days that included Festival of Faith Day; Homecoming and Governor's Day; Fraternal, Nationality and Civic Clubs Day; Youth Day; Industry Day; and Labor and Agriculture Day. A beauty contest crowned 14 sesquicentennial princesses and two queens: Nancy Riegel, Miss Canton Sesquicentennial, and Ann Hadjian, Miss Stark County Sesquicentennial. A highlight of the festivities was a nightly pageant at Fawcett Stadium called Canton-O-Rama. The performance featured 19 episodes on topics, including "This is the Canton Story," "Of Books, Slates, and the Hickory Stick," and "An Era of Progress: The Iron Horse Comes to Canton." Hundreds of Cantonians volunteered to be in the show. By the end of the night, visitors learned the entire history of Canton, from Native Americans to World War II.

Canton's men participated in a sesquicentennial beard-growing contest called "Brothers of the Brush." Local barbers served as judges in several categories, such as longest full beard; blackest, whitest, and reddest beards; most comical beard; best muttonchops; best goatee; and neatest handlebar mustache. There was also a booby prize for the man who tried the hardest and accomplished the least. The winners got something they were sure to appreciate—a jar of shaving cream.

35

While the men were busy growing beards, women participated in "Sisters of the Swish" by dressing like pioneer women. Women could purchase a "cosmetics permit" badge in order to maintain her 1950s-era makeup instead of a more natural look from 1805. Here, "Brothers of the Brush" participant Mark Volak poses for a photograph with several unidentified "Sisters of the Swish."

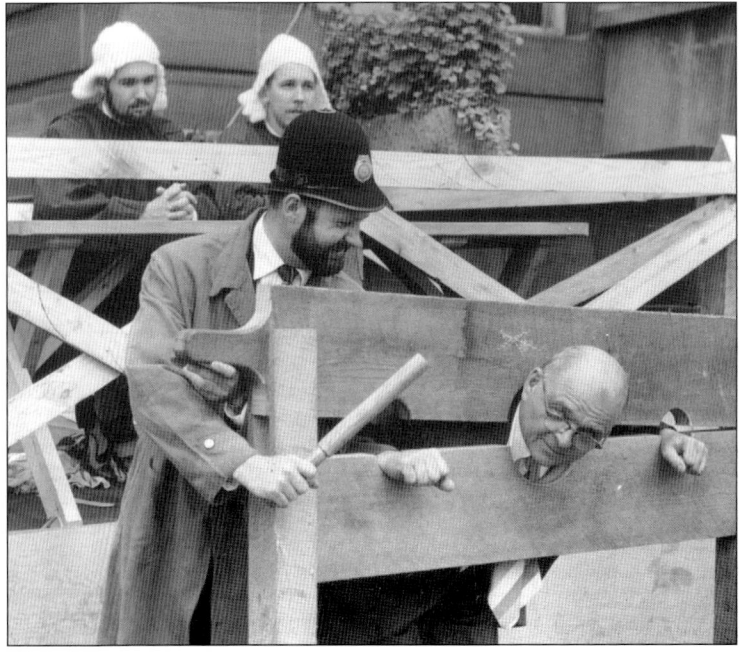

During the sesquicentennial festivities, a stockade was placed in Public Square to publicly "punish" men who were seen without beards during the Brothers of the Brush competition. It was all in jest, of course, but those who were not growing beards still tried to avoid the humiliation. The stockade is now part of the permanent collection at the McKinley Presidential Library & Museum.

The sesquicentennial celebration concluded on August 20 with the largest parade in the history of the city. Jets screamed across the sky, and the air-raid sirens went off to start the parade. Military units, bands, floats, horses, and antique cars filed down city streets. Some of the floats were quite elaborate, costing thousands of dollars to build. Timken sponsored a three-unit red, white, and blue float with a large replica of a roller bearing. The Hoover float featured women sweeping with various models of vacuum cleaners. The Greek-community float highlighted classical Greek architecture with men and women in flowing robes. The Canton Board of Education's float depicted a scene of students at the first Union School juxtaposed with a modern classroom setting. Other spectacles included an eight-foot chicken, street-cleaning equipment from 1885, and early post office vehicles. Despite 90-degree temperatures, a crowd of 100,000 came out in honor of Canton's 150th birthday.

Canton's first Armistice parade was a spontaneous event on November 11, 1918, to celebrate the end of World War I. Fred F. "Sticks" Sanderson, a telegrapher at the *Repository*, was the first to receive the news. At 3:30 a.m., the fire bell rang out, and factory whistles blew. An impromptu crowd assembled at Public Square, ignoring the flu-epidemic ban on congregating. Mayor Poorman announced a grand parade would be held the following afternoon.

In 1938, the McKinley High School Band played in the annual Decoration Day parade. The school is named for the president's sister Anna McKinley, a beloved teacher in Canton. Maj. Gen. John A. Logan declared the first Decoration Day—May 30, 1868—as an occasion to decorate veterans' graves with flowers. Although the term "Memorial Day" appeared as early as 1882, it was not commonly used until after World War II. (Courtesy of Joyce Bair.)

The first Stark County Fair was held October 15–16, 1850, at Public Square. The following prizes were listed in the *Repository*: best-managed farm not less than 40 acres, $10; best stallion, $8; best Merino sheep, $3; and best crop of oats, $4. After moving to various locations in Canton and Massillon, the fair found a permanent home in 1859 at Nimisilla Park (now known as Crystal Park), shown here in 1875. (Courtesy of the Stark County District Library.)

THE Stark County Agricultural Society

EXTENDS ITS COMPLIMENTS TO *U Hanker and One*

FOR THE FAIR TO BE HELD AT CANTON, O.,

September 23rd, 24th, 25th, 26th and 27th, 1889.

NOT TRANSFERABLE.

J. P. LAWRENCE, PRESIDENT. J. F. NIESZ, SECRETARY.

The Stark County Agricultural Society has organized every fair since its inception. Four years after this ticket was issued, a fire broke out the night before opening day, killing most of the livestock. Another fire in February 1894 destroyed the exhibition hall. The society secured a new location at 305 Wertz Avenue NW, where the fair continues to be held today. (Courtesy of Canton Classic Car Museum.)

The produce display shown here was one of many entries in the 1897 fair. In spite of a gradual shift away from horticultural activities, on May 27, 1897, the *Stark County Democrat* reported that a fair official "was not in favor of cutting down premiums on horticultural products and putting them on fast horses. He believes in fast horses, but the Agricultural Society must rely largely for its success on farmers, and to gain their attendance and support, adequate premiums should be paid in every class of farm and garden products."

No matter where the fairgrounds moved throughout the 19th century, a half-mile racetrack was among the first attractions constructed. Spectators enjoyed horse racing, and detailed race times were listed in all of Canton's major newspapers each day of the fair. An article that appeared in the September 2, 1897, issue of the *Stark County Democrat* said, "Notwithstanding bicycles, electric streetcars and railway trains, horses are yet attractive to most persons, whether old or young, male or female. And at the Stark County Fair this year the horses will be there."

In 1917, fair organizers staged an automobile race on the half-mile track, but the considerable dust cloud was such a nuisance that they never had car races again. For a few years, the center of the racetrack was flooded for ice-skating in the winter and drained again in the spring.

The Aero Club organized an aviation meet in September 1911 at the Stark County Fairgrounds, attracting 65,000 people over three days. Famous aviators Harry Atwood, Walter Bookins, Eugene Ely, and Jesse Seligman participated. Bookins opened the meet by setting a world spiral record, straightening out only five feet from the ground. Atwood dropped bags of flour to simulate bombs. Spectators could take rides in an airplane for the staggering sum of $100 per person. (Courtesy of Kent Bedford.)

Canton Skateland was located on Roslyn Avenue NW at the Stark County Fairgrounds. In a 1986 article called "Waiters on Wheels," *Repository* writer Gary Brown said Merle Eckard, of Eckard's drive-in, hired most of his waiters by watching people skate at Skateland. The skating waiters were so fast that Eckard claimed his food was delivered eight times quicker than it would be if carried by a waiter who walked. Eckard also sent his skating waiters to Skateland to practice. (Courtesy of Dawn Walter.)

Over the years, the fairgrounds has continued to grow. In 1900, the grandstand and the art hall, to exhibit arts and crafts, were built. The grange hall was built in 1925 to exhibit vegetables and baked goods. The 1930s saw the construction of several animal barns and the 4-H hall. In the 1970s, the 4-H sheep and swine barn, rabbit barn, and beef-display area were built. A highlight for many fairgoers today is the long line of concession booths and amusement rides, shown in this photograph taken in the 1990s. (Courtesy of Dick Fulton.)

The Sixth Street Pool, which opened in July 1928, was one of three city pools built with a donation from H.H. Timken. Cook Park Pool opened at 1836 Mahoning Road NE in 1927, and the Jackson Pool opened at 1450 Cherry Avenue SE in 1929. The Sixth Street Pool, which was located near Mother Gooseland, closed in the early 1970s. (Courtesy of Dawn Walter.)

Ink Park, located at 2523–3753 Park Drive NW, was a popular picnic spot for Cantonians like Eliz Conklin, Evelyn Fleck, and Ann Charney, pictured here in 1950. The park is named for Harry Ink, and the land was originally part of his estate. Ink invented Tonsiline, a "patent medicine" that was advertised as a cure for sore throat and diptheria, and was the man responsible for building the Palace Theatre. Ink Park is one of many parks still in operation throughout the city. (Courtesy of Linda Todd.)

Jerry and Kelly Milton feed the ducks in the pond at Monument Park, which has been a favorite pastime for generations. If the pond freezes during the winter months, it is also a popular spot for ice-skating. Once the ice is thick enough, city employees clear the snow from the pond and remove the "no skating" sign. (Courtesy of Dawn Walter.)

43

Jerry and Kelly Milton frolic in Monument Park, located adjacent to the McKinley National Memorial. Built between 1905 and 1907 as the final resting place for Pres. William McKinley, the McKinley National Memorial is known locally as the "McKinley Monument." While Monument Park is part of the Canton City Park System, the monument itself is on the grounds of the McKinley Presidential Library & Museum, a private nonprofit organization. All of the land that makes up present-day Monument Park was previously owned by the McKinley National Memorial Association. The deed for the property shows that it was acquired by the city in two parcels—one in 1907, and the other in 1928. (Courtesy of Dawn Walter.)

In 1976, the nation's 200th birthday sparked all kinds of celebrations across the country. Canton hosted several Bicentennial events all over town, including the concert shown here at the McKinley National Memorial. There was also a tour of homes; an International and Ethnic Bicentennial Festival; displays at the Canton Bicentennial headquarters downtown; and "Colonial Fair Days," featuring pioneer arts, crafts, songs, stories, and games.

Three

CLUBS

New Y. M. C. A., Canton, Ohio.

The Canton YMCA held its first meeting on April 16, 1866, in the lecture room of the Methodist church. The first YMCA rooms and library opened on March 13, 1867, on East Tuscarawas Street. The YMCA hosted six lectures that year, featuring some of the best speakers in the country. In 1868, as Schaefer's Opera House was becoming the center of cultural, social, and intellectual life, the YMCA competed with it for the attention of Canton's youth. The YMCA ceased operations in 1880, but six years later a community-wide campaign funded the construction of a new building at the corner of West Tuscarawas Street and Plum Street NW (now known as McKinley Avenue). In 1916, the YMCA moved to this new building at Second Street NW and McKinley Avenue, where it operated until 2008. That building was torn down, and a new building, called the Eric Snow YMCA, is planned for the same site.

45

The YMCA offered a variety of evening classes in topics like mechanical drawing, penmanship, arithmetic, bookkeeping, French, carpentry, photography, clay modeling, music, electricity, automobiling, commercial law, salesmanship, sheet-metal pattern cutting, wireless telegraphy, and business. They also offered English classes for the immigrants who were coming to town to work in Canton's factories. Additionally, the organization sponsored recreational activities, like this 1914 checker tournament.

The YMCA sponsored Canton's first boys' camp in the summer of 1906. After moving around each year, the YMCA secured a more permanent camping spot in 1911 on Mud Lake, which would become Turkeyfoot Lake, in Akron. This photograph of Canton YMCA campers was likely taken at that location.

Although the YMCA had been going strong for more than 50 years, Canton did not get a YWCA until 1909. Anna Lowry Wheeler spoke to her Sunday schoolteacher, Rosina Prior, about organizing a YWCA in Canton. Within two weeks, a meeting was held at the Methodist church to investigate the feasibility of such a venture. By the end of the year, the women had obtained a charter for Canton's first Young Women's Christian Association. Early on, they organized a series of popular classes, including sewing, dress and shirtwaist making, cooking, millinery, English literature, French, German, mandolin, and guitar. The YWCA helped young women who were new in town find living quarters, and the organization held noon meetings for those working in Canton's plants and factories, including Gibbs, Republic Steel, Timken, and Troy Laundry.

The Canton Outing Club was organized in 1892. John C. Dueber, of the Dueber-Hampden Company, was the club's first president. Evidently, the members organized a band, but very little is known about this club.

47

In 1867, John Rex Bucher of the Bucher & Gibbs Plow Company built a home at 822 North Market Avenue, which would later become the Canton Woman's Club. In 1920, the local chapter of the Sorosis Club invited 14 other women's groups to form the Woman's Clubhouse Committee to work together to purchase a place where they could all host club meetings. Among the organizations were the MacDowell Club, the Daughters of the American Revolution, the Farm Woman's Club, the College Club, the Clio Club, and the Ladies Chorus. The Committee purchased the Bucher home for $43,000, and the Canton Woman's Club was incorporated on June 8, 1920. The home retains some of its original woodwork and decorative ceilings, but the Second Empire tower and a front porch were removed prior to the establishment of the Canton Woman's Club.

This Tom Thumb wedding took place at the Canton Woman's Club in 1932. Carolyn Baird, the five-year-old violinist on the right, played "Oh Promise Me" for the ceremony. Tom Thumb weddings were inspired by the 1863 wedding of Gen. Tom Thumb, whose real name was Charles Stratton, and Lavinia Warren. Entertainer P.T. Barnum sensationalized the union of the little people, sparking the trend of simulating the Tom Thumb wedding with children. (Courtesy of Carolyn Baird.)

In 1885, the Canton Bicycle Club had 10 charter members. As wheeling became more popular, the club started to grow. In 1886, the Stark County Bicycle Clubs jointly sponsored a three-day state bicycle meet, with one day each in Massillon, Canton, and Alliance. In those days, everyone was still riding the high-wheeler bicycle, and 100 wheelmen came from across Ohio to participate in the state meet.

In 1888, the so-called "safety bicycle" was introduced. It had two wheels of the same size and was considered a much safer ride. Before the invention of the safety bicycle, all of the riders of the high-wheelers were men. It was not easy for a woman to ride a bicycle at that height while wearing a long skirt. Women began riding the safety bicycles when the center bar was dropped to accommodate their attire. People often took bike excursions around the city and surrounding countryside. Members of the Century Club were admitted after riding 100 miles on a bike within a 24-hour time limit.

The Aero Club of Ohio was organized in 1907 by Frank S. Lahm, a Canton native who had a lifelong interest in flight. At the time, flight was a novelty, and there were only a handful of aero clubs operating throughout the country. The club's activities regularly made the front page of the *New York Times* and other major newspapers.

On December 20, 1907, a crowd of over 10,000 people congregated at the corner of Walnut Avenue and Seventh Street SE to witness the first balloon ascension of the Aero Club. At 3:15 that afternoon, the balloonists crossed the Ohio state line at the Mahoning River. The *Repository* published two extras reporting on the search for the balloon after losing track of its location. Finally, at 7:11 p.m., a Western Union message arrived from Lahm: "Landed three-forty, eight miles north of New Castle [PA]. Beautiful trip. See you soon."

Balloons that flew out of Canton included the *Ohio*, the *Sky Pilot*, the *Buckeye*, *All America*, and *You and I*. They were filled with artificial gas (rather than hot air) and launched from the old gas plant on Walnut Avenue. The club was always trying to make flights as long as possible, both in distance and in time. The Aero Club focused on ballooning until 1909, when heavier-than-air flight became popular.

This photograph shows members of the Chocolate Club in the 1890s. This group of young women reigned supreme in Canton's social world. With the boys' club, Junior Assembly, they held elaborate summer dances and picnics at Meyers Lake and winter parties at Bast Hall. Dressmakers spent weeks making intricate gowns for Chocolate Club members. It is unclear why they chose the Chocolate Club as their name, but it may have been associated with the elite reputation chocolate enjoyed in Europe. Pictured from left to right are Mary Barber Hartzell, Bessie Barr Kimbark, Louise Griffeth Parrett, Hattie Crum Clark, Jo Barnabay, Rae Frease Green, Alice Lynch Alexander, and Frances Lynch Miller.

The Clio Club was a social group for society women that met twice a month for the purposes of education and camaraderie. The women took turns presenting programs and giving lectures to each other on a wide range of topics, including family and health, American authors, bees, modern meteorology, and the Socialist Party in France.

The Canton Lodge of the Loyal Order of Moose was founded in May 1910. The first meetings were held in Bast Hall on North Market Avenue and later in the Harter building on Public Square. The Moose purchased the old YMCA building on the corner of West Tuscarawas Street and McKinley Avenue SW in 1916 and remained there until the 1930s. After a fire destroyed the group's rented space on Second Street NE in 1953, they bought the former Blue Arrow Club on Thirteenth Street NW. In 1969, the Moose built a lodge at 3300 Parkway Street NW. In the 1980s, the Canton Moose boasted the second-largest membership in Ohio. The club held card nights, dinners, and dances for its members and their wives.

Founded as an exclusive businessmen's club, the Canton Club was originally located in the St. Francis Hotel. In 1923, it moved to the top floors of the First National Bank Building, later known as the Chase Building, across from the Stark County Courthouse on West Tuscarawas Street. The Canton Club is no longer a private club but now functions as an event center with limited restaurant dining hours.

53

The MacDowell Club was founded in 1908 to advance the "art and appreciation of music and to stimulate musical culture in Canton," according to an advertisement placed in the 1955 sesquicentennial commemorative booklet. The group's namesake, Edward Alexander MacDowell, was an American composer who died the year the club formed. This is one of the earliest photographs of the club, which still exists today. Membership comprises two categories: performing and associate (for those who do not play an instrument or sing).

Four

CULTURAL ORGANIZATIONS

Some of the earliest organized entertainment in Canton was provided by singing societies started by the German immigrants who settled this region. The first group, called Harmonie, performed their first concert in July 1810. Other 19th-century groups included Canton Liederkranz (1832), Concordia Singing Society (1865, named for the ship that brought the first German settlers to the New World in 1683), and Canton Mannerchor (1871). The singing societies were among the most stable social groups, appearing year after year in the city directory. In 1871, all of the individual singing societies worked together to build the German House, or Deutsche Haus, which featured a 600-seat theater, meeting rooms, and a bar. In 1894, the individual singing societies combined to form the Arion Singing Society, which still exists today, although the club's building was recently sold.

The Canton Operatic Club was active from 1908 to 1923. The group performed once a year at the Grand Opera House to sold-out crowds. Although the musical director, stage director, and musicians were paid, the entire cast of each performance was made up entirely of volunteers. Proceeds went toward a large banquet after the show, with the remainder earmarked for local charities. The four drummers pictured here performed in the 1917 production of *The Fortune Teller*.

The Canton Civic Opera was founded in 1939. Boris Goldovsky was the first director, and Lona Basil Thurin was the first president. Their first opera, *The Bartered Bride*, was held at the Timken Vocational Auditorium on January 19 and 20, 1940. This promotional photograph was done for the production of *The Great Waltz* in 1966. The Canton Civic Opera changed its name to Voices of Canton, Inc. (VOCI), in 2003 to better reflect its more diverse musical offerings.

The Canton Art Institute, now known as the Canton Museum of Art, originally occupied one small room on the second floor of the Canton Public Library in 1935. Four years later, a secret benefactor made it possible for the institute to make the Frank E. Case Mansion its new, permanent home. Upon his death, it was made public that Fred A. Preyer was the anonymous donor.

In 1970, the Canton Art Institute moved to the newly constructed Cultural Center for the Arts, which would also became the home of the Player's Guild, the Canton Ballet, and the Canton Symphony Orchestra. Architects Lawrence, Dykes, Goodenberger & Bower designed and built the structure on land known as the Harter Estate. The Cultural Center is adjacent to the Civic Center (formerly known as the Canton Memorial Auditorium), which was built in 1951.

> You are invited to attend
>
> # CASINO ROYALE
>
> presented by
> The Museum Guild of The Canton Art Institute
> Saturday, January 12, 1980 8:30 pm - 1:00 am
> at The Canton Art Institute
> Featuring games of chance and entertainment
> Proceeds to benefit The Canton Art Institute
>
> **Patron tickets $50.00 per person**
> Cocktails and dinner
> 6:00 p.m. Cable Recital Hall
> Admission to Casino
> Free Parking
> Reservation Deadline January 4th
>
> **General tickets $10.00 per person**
> Admission to Casino
> Cash bar 8:30 p.m.-1:00 a.m.
> Reservation Deadline January 10th
>
> Please use enclosed card
> Tickets will not be sold at the door
>
> *NEW ATTRACTIONS! Gay Nineties Revue and Bingo*

In 1977, Jane Fawcett became the first president of the Museum Guild of the Canton Art Institute. A core group of 35 women started the group as a volunteer fundraising and public-relations organization. One of the guild's first activities was Casino Royale, featuring an evening of games and entertainment, on December 10, 1977. The group raised $15,000 that night for gallery programs at the museum. (Courtesy of the Canton Museum of Art.)

In 1981, the Museum Guild introduced a popular lecture series called "Town Hall," which brought many high-profile speakers to town. In 1982 and 1983, presenters included, from left to right, William Buckley, Maureen Reagan, Vincent Price, and Ginger Rogers. Other speakers included Beverly Sills, Frank Blair, Kitty Carlisle, Douglas Fairbanks Jr., Willard Scott, and Art Linkletter. The lectures were held at the Palace Theatre. (Courtesy of the Canton Museum of Art.)

From February to April 2009, the Canton Museum of Art hosted one of the largest exhibitions in its history—Kimono as Art: The Landscapes of Itchiku Kubota. The centerpiece of the exhibition, Symphony of Light, comprised of 30 kimonos: 15 representing autumn and 15 representing winter. It was Kubota's vision to create each of the four seasons, but he passed away before beginning spring and summer. The kimonos were created using the lost art of *tsujigahana*, an ancient and complex tie-dyeing technique. Each kimono in Symphony of Light flowed into the next, creating a landscape image when viewed together. The exhibit sparked a total of 80 kimono-inspired cultural events throughout Canton, ranging from Japanese tea ceremonies to sumo wrestling. (Courtesy of the Canton Museum of Art.)

The Player's Guild was organized in 1932 by Bernard and Florence Truxton. Without a theater of its own, plays were performed in the Jewish Center and in the old Masonic Temple until 1937. For the next few years, the Player's Guild performed in whatever venue was available. In 1940, the Case Mansion Coach House, shown here, became its home until the Cultural Center for the Arts was completed in 1970. The Player's Guild is one of the oldest volunteer-based theater groups in the country.

These unidentified tiny ballerinas were part of a Player's Guild production in the 1950s. Since 1932, the Player's Guild has produced more than 600 shows for an estimated 2,000,000 people. Productions have included Mame, The Wizard of Oz, Les Miserables, Beauty and the Beast, Annie, and The Full Monty. One of the most beloved holiday traditions in Canton is the annual production of A Christmas Carol.

The Canton Symphony Orchestra was formed on January 26, 1938. Richard W. Oppenheim was the first director. The symphony held its first concert on February 16, 1938, at the Auditorium, which became their concert hall until the building was condemned in 1940. After that, the orchestra played in various high school auditoriums.

Louis Lane, who had previously held the position of assistant conductor of the Cleveland Orchestra, became the Canton Symphony Orchestra's second music director in 1949. The Canton Youth Symphony began in 1961 and performs at the GlenOak High School Theater. Since 1963, the Symphony League of Canton has provided volunteer and financial support for the Orchestra. (Courtesy of the Canton Symphony Orchestra.)

Canton
SYMPHONY ORCHESTRA
cso

LOUIS LANE
Conductor

THE THIRTEENTH SEASON
1949 1950

Wednesday, March 8, 1950

Timken Vocational High School
CANTON, OHIO

Gerhardt Zimmermann, the Canton Symphony Orchestra's current music director, came from the St. Louis Symphony in 1980. All members of the organization are professional musicians, and an active education department plans youth concerts, in-school performances, summer camps, and a series of free interactive programs called Listen at the Library in partnership with the Stark County District Library. (Courtesy of the Canton Symphony Orchestra.)

Founded in 1946, the Stark County Historical Society did not have a place to call home for many years. Early staff members worked out of donated space in downtown office buildings. There was no actual museum to visit at first, but soon the organization hired an architect to plan Stark County's first historical museum. When ground was broken for the new building in 1962, the historical society began to rapidly expand. Between 1946 and 1961, the museum received only 628 artifact donations, but from 1962 to 1965, it collected 3,365 objects. The museum finally had space to display cherished heirlooms from Stark County's past in the Historical Hall and McKinley Gallery. Today, the Historical Society does business as the McKinley Presidential Library & Museum. (Courtesy of Linda Todd.)

Marie Curry, one of the museum's first curators, holds a teacup in the McKinley Gallery, which houses the largest collection of McKinley-related artifacts in the world. The museum's founders created this space to honor the legacy of the 25th president of the United States. To better identify with Canton's presidential heritage, the museum became a presidential library in 2003.

When designing the new building, museum officials traveled to hundreds of museums across the country to gather ideas. The Hoover-Price Planetarium was part of the museum's original design. The exterior of the planetarium dome was camouflaged with a flat roof so it did not visually compete with the McKinley National Memorial.

An addition to the museum building in 1980 created a new space for science exhibits. In 1990, the science center was redesigned by Applebaum & Associates to create Discover World, which consists of three sections: Natural History Island, Ecology Island, and Fascination Station (formerly Space Station Earth). Alice the Allosaurus, a roaring animatronic dinosaur, is the star of Discover World.

The 1980 addition also allowed the museum to add a new historical gallery to the second floor, called the Street of Shops. This photograph shows the beginning of the construction process, with only the fireplace that would become part of the cabin exhibit. As funding became available, shops were added, culminating with completion of the schoolhouse and railroad station facade in 2002.

Victoria Christea and George Barb were married on April 30, 1938. After the ceremony, the wedding party and all of their guests walked two and a half miles to the McKinley National Memorial to take this photograph. Although it is a presidential burial site, Canton views the monument as an active part of the community. Built between 1905 and 1907, the monument has been owned and operated by the Stark County Historical Society since 1973.

The Saxton House, the childhood home of First Lady Ida McKinley, is now a historic house museum operated by the National First Ladies Library. The home at 205 South Market Avenue was built by Ida McKinley's grandfather John Saxton in the 1840s. By the 1970s, the home was barely recognizable after decades of use as a commercial building. A painstaking restoration revealed the original facade, and it was listed in the National Register in 1979.

This 1937 Studebaker President bulletproof police car, used by the Canton Police Department, is now part of the collection of the Canton Classic Car Museum. It features one-inch-thick glass with closable portholes to fire Tommy guns. The museum features more than 40 vehicles, plus vintage advertising, toys, and thousands of pieces of Canton memorabilia. Open to the public since 1978, the Canton Classic Car Museum is housed in a former 1914 Ford dealership at 123 Sixth Street SW. (Courtesy of the Canton Classic Car Museum.)

Five

HOTELS

Francis A. Onesto opened the Onesto Hotel, located on the corner of Second Street NW and Cleveland Avenue, in 1930. It featured all the amenities of the modern age—high-speed elevators, hand-type telephones in every room, and an array of shops and services on the ground floor. Today, it is being converted into luxury apartments.

Consider
"THE ONESTO" *Your Hotel*

ROOMS { SINGLE $3.00 AND $3.50
DOUBLE 4.50 AND 5.00
TWIN BED ROOMS—6.00

200 OUTSIDE ROOMS ALL WITH BEAUTIFUL TILED BATH TUB OR SHOWER — CIRCULATING ICE WATER — OSCILLATING FANS — R. C. A. RADIO IN EVERY ROOM — SIMMONS BEAUTY REST MATTRESSES — FINEST FURNISHINGS AND EQUIPMENT

McKINLEY ROOM

A BEAUTIFUL PRIVATE DINING ROOM OR MEETING ROOM

CRYSTAL DINING ROOM & JUNIOR BALL ROOM

BEAUTY SHOP
BARBER SHOP
LADIES LOUNGE
COFFEE SHOP
GARAGE HANDY
HIGH-SPEED ELEVATORS
ALL ROOMS EQUIPPED WITH HAND TYPE TELEPHONES

100% COMFORT AND CONVENIENCE WHEN IN CANTON

Onesto Hotel—Opened August 20, 1930

ONE OF AMERICA'S MOST MODERN AND BEST EQUIPPED HOTELS

ONESTO HOTEL
FRANCIS A. ONESTO
President & Managing Director

67

THE BEAUTIFULLY DECORATED AND SPLENDIDLY FURNISHED LOBBY LOUNGE

The Onesto Lobby was described in a promotional brochure as "beautifully decorated and splendidly furnished" in the Italian Renaissance style. With travertine terrazzo and walnut trim, it rivaled any hotel lobby to be found in a city much larger than Canton. The hotel also advertised a barbershop, coffee shop, and a ladies' lounge.

McKINLEY ROOM, SHOWING PAINTINGS OF EVENTS IN LIFE OF FORMER PRESIDENT

The McKinley Room at the Onesto featured several large paintings by artist William Findley depicting events in President McKinley's life. Today, two of those paintings are part of the permanent collection of the McKinley Presidential Library & Museum and are on loan to the Stark County Courthouse. The McKinley Room was used for private dining, wedding receptions, banquets, and dances.

SINGLE ROOMS ARE COMFORTABLE AND WELL VENTILATED

The Onesto boasted 200 guest rooms. Single rooms with twin beds were described as "comfortable and well ventilated." Amenities included a tiled bathtub or shower, circulating ice water, oscillating fans, an RCA radio, and a Simmons Beauty Rest mattress in each room. A room like this would have cost between $3 and $3.50 per night when the hotel first opened.

PLAN OF STREET LEVEL FLOOR SHOWING SHOPS

This floor plan for the Onesto Hotel shows the second floor, where the hotel lobby was located, and the first floor, which featured retail spaces for six shops and a restaurant. The lobby level was also the location of the front desk, telegraph office, beauty shop, ladies' parlor, and the Crystal Dining Room.

PLAN OF THE SECOND, OR LOBBY FLOOR OF THE ONESTO

The Town Shop was one of the stores located on the street level of the Onesto. It was owned by Maurice Rapport, a Russian immigrant who owned a chain of women's clothing stores in Western Pennsylvania and Northeast Ohio. He also owned a shop called Rapport's. Based on the clothing worn by the mannequins in the window, this photograph of the Town Shop is from the 1940s.

DAY OR NIGHT
Two Passengers 25¢
ADDITIONAL PASSENGERS 10¢ EACH
Dial 8904
We Carry Liability Insurance
4 Door Sedans - Drivers No. *Red*
CHECKER CABS
BAGGAGE SERVICE
PAUL BARNARD, Mgr. Private Stand at Onesto Hotel

Advertised as "one of America's most modern and best equipped hotels," the Onesto had a private Checker Cabs stand for the convenience of its guests. It cost 25¢ for two passengers to ride a four-door sedan, with an additional 10¢ charge for each passenger after that. Guests could dial the stand from their rooms and take advantage of the company's baggage service. (Courtesy of Jerry Novak.)

In 1905, architect Guy Tilden designed the Courtland Hotel at 209 West Tuscarawas Street, next to the Stark County Courthouse. It featured 150 rooms and was considered "the headquarters of the traveling public" in a 1922 booklet about Canton published by Herman R. Witter. The hotel featured a reading room, a telephone exchange in the lobby, and hot and cold water in each room.

The hotel's proprietor, W.S. Langford, described the Courtland Hotel's dining room as "the most beautifully decorated and arranged of any such room to be found." A 1912 menu listed codfish and cream on toast, calf's liver with bacon, and imported frankfurters with horseradish among the evening entrees. Many important gatherings took place in the dining room, including the meeting to organize the National League of Professional Football Clubs in 1921.

71

The Courtland was renovated and renamed the St. Francis in the 1940s but soon fell on hard times. In 1960, the county purchased the building and turned the former grand hotel into office space. In 1985, *Repository* reporter Louise Johnson described the structure as "an aging queen with her crown askew and a rip in her dress." Today, all that remains of the Courtland Hotel is the archway of the front entrance, just west of the Stark County Courthouse on West Tuscarawas Street. This photograph was taken in 1955 during Canton's sesquicentennial celebration.

The McKinley Hotel opened in 1901 at the corner of South Market Avenue and Third Street (which was known as Eighth Street until the downtown streets were renumbered in 1913). Its location near the Grand and Lyceum Theatres made it an ideal stopover for traveling performers such as Al Jolson, Elizabeth Risdon, and Rudolph Valentino. Pres. Teddy Roosevelt also stayed there while in town for a celebration honoring Pres. William McKinley in 1903. The hotel fell into disrepair and was razed in 1972 to make room for more downtown parking. In its last days, it served as a home for more than 100 residents, most of whom were senior citizens. (Courtesy of Dawn Walter.)

The Barnett Hotel was built in the 1880s and quickly became a fashionable place to live as well as a popular spot for banquets. An 1892 advertisement in the *Repository* read, "The Barnett has been remodeled and refurnished new throughout. Strictly first-class in all its appointments. Electric bells, electric light and heated by steam. Streetcars pass the doors to all depots. Centrally located, and has the finest sample rooms of any hotel in the city. Rates $2.00 to $2.50 per day." An 1897 menu offered baked blue fish, prime roast of beef au jus, fresh lobsters a la Newburg, and small oyster patties. The Barnett became the Milner in the 1930s and the Drake in 1959. A fire destroyed the hotel in May 1960.

Hotel Belden was located at Sixth Street and North Market Avenue. The Knights of Pythias opened the hotel in 1921 under the name the Northern. It featured "circulating drinking water" and "shower and tub baths" in all of its 110 rooms, according to an advertisement in the *Canton Daily News*. It became the Belden in 1935 when Paul B. Belden purchased it. The hotel's restaurant was called the Purple Cow, which was remembered as the "last stopping point" for GIs heading off to fight in World War II. In the 1960s, Ray Buttermore played the organ every night in the hotel's Viking Room. The building was razed in July 1978.

Six
OPERA HOUSES AND THEATERS

In February 1867, Louis Schaefer announced plans to build an opera house across the street from the courthouse in Canton. At the time, Comstock's, located in Columbus, was the only opera house in the state. The town was divided about this proposed addition to their community. The English-speaking churches were very much against it, while the German-speaking churchgoers, Catholics, and nonchurchgoers were in favor of it. Plans moved forward, and 150 couples attended the opera house's grand inaugural ball in February 1868.

Schaefer was quite a character. Before every performance in his opera house, he spoke for up to an hour on any subject that struck his fancy. He once lamented about the high tariff on raisins. He particularly enjoyed providing the audience with a scathing-yet-witty characterization of his political enemies. When attendance was particularly low, he spent most of his curtain speech criticizing the people of Canton for their lack of appreciation for the show he had diligently arranged for them.

Schaefer's Opera House hosted some "high class events," including Hamlet, The Merchant of Venice, and Uncle Tom's Cabin (Schaefer's name is misspelled on this handbill). It also featured some more popular shows, like The Streets of New York and Rip Van Winkle. Tickets sold for 25–50¢ apiece. Schaefer had many ties with the entertainment business, which brought many well-known actors of the period to Canton that would pass over other towns of similar size.

MISS RACHEL DENVIL & MORTIMER MURDOCK,

In the great Moral Temperance Drama of

TEN NIGHTS IN A BAR-ROOM!

DOORS OPEN AT 6-45. COMMENCE AT 7-30.

PRICES OF ADMISSION.—Floor and Balcony Seats, 50 Cents. Orchestra and Balcony Circle, Reserved 75 Cents. Private Box $5.

Seats may be secured in advance. Office, North-west corner of the Block, upstairs. Office open from ... to ... p.m.

Schaefer booked many controversial lectures and performances, including the antialcohol morality drama *Ten Nights in a Bar-Room* and a debate on "The Impracticality, Absurdity, and Bigotry of the Second Amendment." He was well known for being an atheist and was fond of scheduling popular shows in the same time slot as religious services.

Marietta Ravel, a famous dancer, mime, and tightrope walker, performed at Schaefer's Opera House in several numbers in a single evening. Schaefer was a fixture at his opera house until his death in 1889. Once the larger and more modern Grand Opera House opened in 1890, Schaefer's Opera House became obsolete. The building was converted to an office building and burned down in 1951.

OVERTURE, - - - ORCHESTRA.

After which **MARIETTA RAVEL** will perform her wonderful act upon the

TIGHT ROPE!

WITHOUT THE AID OF A BALANCE POLE.

To Conclude with the exciting drama, entitled the

Dumb Girl of Genoa,

Julietta. - - - Marietta Ravel.

DESPERETTA, . . P. E. CONNOLLY. | Strapado, the Drunken Corp'ral Maj. H. Lindley.
Count Corvenio, . . M. T. W. Keene. | Antonio, . . . John Nunan
Justin, . . . Mr. Frank Rosworth. | Moco, . . . Mr. Frank Barry
Jaspen, . . . Mr. E. J. Gilman. | Whiskeris, . . . Mr. Ward.

During the Drama a Grand

Black Crook Pas Seul!
BY MARIETTA RAVEL!

As danced by her over Two Hundred Nights.

Musical Combat
Between Marietta Ravel and P. E. Connelly,

AND A GRAND

DRUNKEN COMBAT
Between STRAPADO & DESPERETTA

DOORS OPEN AT 6-45. COMMENCE AT 7-30.

PRICES OF ADMISS... Floor and Balcony Seats, 50 Cents. Orchestra and Balcony ... ved, 75 Cents. Private Box $5.

Grand Opera House, Canton, Ohio.

Located at 130 Third Street SE, behind the McKinley Hotel, the Grand Opera House opened in October 1890 with a stage that was said to be the largest in Ohio. Stockholders included such notable Cantonians as William McKinley and his brother-in-law George D. Saxton.

At the Grand Opera House, the scenery was raised up instead of sliding on and off stage, and the curtain was a representation of Lake Como in Switzerland. Nearly every surface was finished in gold and bronze, with polished brass railings and plush seats. The first performance was the comic opera *Fauvette* by the Boston Ideal Opera Company. One of the most elaborate events held at the Grand Opera House was the McKinley birthday celebration on January 27, 1903. More than 450 guests paid $15 a plate to attend the dinner sponsored by the Canton Republican League. Pres. Teddy Roosevelt was the keynote speaker.

The Grand Opera House featured D.W. Griffith's *The Birth of a Nation* in October 1918. The controversial silent film had debuted in 1915, but it was not immediately shown in Canton because it had been banned by Ohio's governor. Based on the novel and play *The Clansman*, *The Birth of a Nation* was accompanied by a 20-piece orchestra, a popular method for adding sound during the silent-film era.

As attendance at live shows began to decline, the Grand became a movie theater in 1927. Toward the end, the Grand showed programs that were "mostly on the seamy side," according to the *Repository*. The theater closed in 1945, and the Bethel Temple purchased the building the following year. The Grand was used as a church until 1958, when the Bethel Temple congregation finished construction of a new building on Twenty-fifth Street NW. It was torn down in 1959.

The Northern Ohio Traction & Light Company opened the Park Theatre at Meyers Lake in May 1906 with an impressive array of live performances, including jugglers, magicians, comedians, and a pantomime act. Famous vaudeville stars Dorothy Vaughn; the Marx Brothers; and Joe, Myra and Buster Keaton all performed at the 1,200-seat theater.

This 1918 advertisement for the Park Theatre featured March's Musical Merry Makers, a popular act on the vaudeville circuit. A matinee of *Buster Brown* provided a family-friendly show for the kids. The Park Theatre was exclusively devoted to live entertainment, but throughout the 1920s, vaudeville began to decline. The Park Theatre closed in August 1926 with a final show called *Pretty Baby*, starring Mary Farrel and Jimmy Hodges.

When the Alhambra opened in 1913 at 332 North Market Avenue, it became the first theater in Canton built specifically for motion pictures. Other theaters in town played movies, but they also offered a variety of live stage shows. The Alhambra celebrated its first Christmas by giving a present to each woman that came into the theater every weekday afternoon. A special pitch urged the ladies to come in for a rest when they were tired of Christmas shopping. This photograph of the theater was taken in September 1915 when the movie *The Climbers*, starring Gladys Hanson and Walter Hitchcock, was playing.

The Alhambra was renamed the Ohio Theatre in the 1930s. In this photograph, taken in 1956, the "Air Conditioned" sign promises welcome relief from hot summer weather. Reinco Theaters took over the space in 1965 and continued to show first-run films. The company remodeled the building after a severe fire in 1969, but it closed in 1976.

The Majestic Theatre was torn down in 1912 to make way for the 1,200-seat Lyceum at 406 East Tuscarawas Street. This rare photograph shows the construction crew of the W.C. Owen Company in Cleveland on the roof, as well as a sign advertising three vaudeville shows daily at 2:30, 7:30, and 9:00 for 10¢, 20¢, or 30¢. The sign also announced pictures on Sunday from 1:00 to 10:00 p.m. In the early days of motion pictures, short films would have featured anything with movement, such as Niagara Falls or storm clouds gathering.

PAGE — — — — — FIVE

Lyceum Summer Policy

Pictures : Pictures : Pictures

Exclusive Art Craft, Paramount and World Programs

With Sunshine, Keystone, Mutt and Jeff, Christie and Fatty Arbucle Comedies

The Pick of the Stars

SUNDAY, JUNE 2
KITTY GORDON in "THE INTERLOPER"
CHRISTIE COMEDY and PATHE WEEKLY

MONDAY AND TUESDAY, JUNE 2 AND 3
MARY PICKFORD in "THE POOR LITTLE RICH GIRL"
Latest Pathe Weekly.
"WILD WOMEN AND TAME LIONS"
a Sunshine Comedy

WEDNESDAY AND THURSDAY, JUNE 5 AND 6
DOUGLAS FAIRBANKS in "WILD AND WOOLLY"
Pathe Weekly and a Sunshine Comedy

FRIDAY AND SATURDAY, JUNE 7 AND 8
MARGUERITE CLARK in "THE AMAZONS"
Latest Pathe Weekly.
"A LADY KILLER'S DOOM"
a Keystone Comedy, with Maude Wayne.

SUNDAY, JUNE 9
"THE CABARET"
with Carlyle Blackwell, June Elvidge, Montagu Love, John Bowers, George McQuarrie
Pathe Weekly and a Christie Comedy

This 1918 advertisement for the Lyceum shows how often early movie theaters changed their showings. In a single week, Cantonians could view films featuring silent-movie superstars like Mutt and Jeff, Fatty Arbuckle, and Douglas Fairbanks in just one downtown theater. *The Poor Little Rich Girl*, starring Mary Pickford, became a Library of Congress choice for preservation in the National Film Registry in 1991.

GLORIFIED BURLESQUE

STATE THEATRE

ADMIT TWO | ADMIT TWO

412 TUSCARAWAS STREET, E.
CANTON, OHIO

SPECIAL COURTESY PASS

GOOD ONLY WEEK OF..

ISSUED TO..

ACCOUNT..

Signed..

Not Good Saturday or Holidays
Exchange at Box Office After 7:00 P.M. on Date of Use
Subject to Service Charge and Local Taxes

The Lyceum Theatre later became the State Burlesque. Photographs of the State are extremely rare, but this "special courtesy pass" for two survives. Billed as the "Home of Burlesque's Top Exotic Stars," the State featured performers like Busty Russell and Chesty Morgan. It closed around 1981. (Courtesy of the Canton Classic Car Museum.)

Built by architect J. Matthew Bostich in 1907, the Orpheum was located at 205 East Tuscarawas Street, where Stark Dry Goods Company and then O'Neil's later stood. The theater featured the finest live Vaudeville acts, including jugglers, magicians, and comedy sketches, as well as silent movies. A representative from Warner Bros. visited the Orpheum in 1923 to conduct an experiment. According to historian E.T. Heald, "Several local citizens were coached to talk in synchronization with pictures that were thrown on the screen. The results were ludicrous." The Orpheum operated until 1930.

ORPHEUM

SUNDAY ONLY

RAY STEWART in "BOSS OF LASY Y" a Western Thriller. "HIS HIDDEN SHAME" two reel Keystone Comedy. Plain Dealer Magazine.

MONDAY–TUESDAY

"ONE HOUR," sequel to Three Weeks, full of ginger. Mutt and Jeff and Christie Comedy.

WEDNESDAY & THURSDAY

"THOSE WHO PAY," with Bessie Barriscale. Billy Rhodes Comedy and Reel Life

FRIDAY-SATURDAY

CHARLIE CHAPLIN in "CHASE ME CHARLIE," a new one; also BRONCHO BILLY in "A WILD RIDE."

ALHAMBRA

SUNDAY—MONDAY

Alhambra presents
GLADYS LESLIE in
"LITTLE RUNAWAY"
Vitagraph Blue Ribbon
also the great and only
HAROLD LOYD
in one of those great comedies

TUES., WED. and THURS.

Rex Beach Great Picture
"HEART OF THE SUN SET"
also first showing of
BRITAIN'S BULWORKS

FRIDAY-SATURDAY

ALICE BRADY in
"THE SILENT SACRIFICE"
also
MR. and MRS. SIDNEY DREW
in one of the Nice Home Made Comedies

This advertisement for the Orpheum and the Alhambra shows a cross section of the kinds of films people could see in the theater in 1918. The Orpheum was running *Chase Me Charlie*, a compilation of short films starring Charlie Chaplin, including *The Tramp*, *Shanghaied*, *A Night Out*, and *His New Job*.

The Dueber Theatre was located at 112 Dueber Avenue SW, on the site where McDonald's now stands. It operated from 1942 to 1963. This advertisement for *The Roman Spring of Mrs. Stone*, starring Warren Beatty and Vivien Leigh, and *Sergeants 3*, starring Rat Pack members Frank Sinatra, Dean Martin, Sammy Davis Jr., Peter Lawford, and Joey Bishop, is from 1962. (Courtesy of Linda Todd.)

The Strand opened in 1917 and was the first theater in Canton to show a movie with sound. Sound for many of the early talkies was provided on a record to play along with the film, which was still silent. A simple sneeze in the projection booth could jostle the needle enough to throw the sound out of sync with the movie. Once sound was added to the film itself, mishaps like this were a thing of the past. The Strand was located at 139 South Market Avenue, across from the Valentine Theatre. This photograph was taken in 1956.

STRAND THEATRE
The House of Quality

WEEK STARTING SUNDAY, APRIL 17 — We Show Nothing but the Biggest and the Best

POLA NEGRI and Cast of 5000　　PASSION　　Two Years to Produce
The Famous Continental Star in　　　　　　　　Love, Laughter, Tears

9 REELS THAT SEEM BUT 5

The Romance of a Strong Man and a Wilful Woman. The true story of the little French Milliner whom the whole world came to know as Madame Du Barry.

Intimate Drama — Mighty Spectacle — De Luxe Presentation — Augmented Orchestra

First National Attraction — Don't Miss This. One Week Only. Come Early.

This 1921 advertisement for the Strand is publicizing the film *Passion*, "9 reels that seem but 5," featuring the "romance of a strong man and a willful woman." Although ticket prices in the early days varied from 30¢ to 50¢, in the 1930s tickets for *Grand Hotel* starring Greta Garbo and John Barrymore cost a whopping $1.50. As noted in this advertisement, the Strand showed "nothing but the Biggest and the Best."

The nationwide Loew's chain opened its Canton location on February 19, 1927, at 518 North Market Avenue. The first movie shown was the silent film *The Waning Sex*, starring Norma Shearer and Conrad Nagel. Loew's also featured live Vaudeville shows. The first stage production included Peggy English, "The Bluest of the Blues Singers"; Art Landry and his Victor recording orchestra; and Ziegfeld Follies dancing star Rita Owin. With seating for more than 2,140, Loew's was Canton's largest movie theater.

The Glass Key, starring George Raft, Edward Arnold, and Claire Dodd, came to Loew's for four days in 1935. Based on the hardboiled detective novel by Dashiell Hammett, the story was brought to the silver screen by Adolf Zukor, founder of Paramount Pictures. (Courtesy of Canton Classic Car Museum.)

86

In 1953, Loew's became the first theater in town to introduce three-dimensional, or 3-D, movies. According to an article in the *Repository*, each pair of glasses loaned to a movie patron was "sterilized between showings." The article wrongfully predicted 3-D movies would become "the rule rather than the exception." Those first 3-D movies were a series of short films, including a trip down the Thames River in England, a ballet called *The Black Swan*, and a British satire with special effects. The Ohio theater had the honor of showing Canton's first full-length feature 3-D film, *Bwana Devil*. Loew's closed in 1975 and was torn down in 1977.

Architects created some of the most lavish and opulent structures of the 1920s when they built huge movie houses. Canton's Palace Theatre opened on November 22, 1926. The starry night sky ceiling, Spanish styling, and soft lighting exemplified the best of atmospheric design. A state-of-the art hanging-stage system could hold 82 different sets at the same time. (Courtesy of the Palace.)

Although the Palace was one of many downtown theaters, it remained the only one with an atmospheric design. As many of its downtown neighbors closed their doors, the Palace shut down in 1976. One week before its scheduled demolition, the Canton Jaycees stepped forward to save the building. In 1980, Canton saw the return of the familiar Palace name in lights. Today, the Palace hosts 100,000 people a year at 300 events. (Courtesy of the Palace.)

The Palace's Kilgen organ is the only one in the country still in its original location. Theaters installed organs to provide accompaniment for silent movies. During the 1970s, a roof leak caused major water damage to the organ. Charles Kegg, Clark Wilson, Charles Blair, and Robert Beck (shown here) repaired the Kilgen so it was playable for the Palace's reopening in 1980. The organ was fully restored in 1992. (Courtesy of the Palace.)

The Stark Drive-In was one of the first drive-in movie theaters in the Canton area, first appearing in the 1950 edition of the Massillon city directory. Although it was located slightly out of town at 2416 Lincoln Way East, Cantonians have fond memories of the novelty of watching a movie in one's car. The North Canton Auto Theatre opened a few years earlier and first appeared in the city directory in 1948. (Above, courtesy of Gary Nist; left, courtesy of Linda Todd)

Seven
RESTAURANTS

Little's Model Dining Hall was located at 224 East Tuscarawas Street. Their sign advertised a "good warm meal for 25¢." They also offered meals "at all hours" and offered choice cigars, hot coffee, cold lunches, and ice-cold milk by the glass.

MODEL DINING HALL
No. 3 East Tuscarawas Street, CANTON, O.
WARM MEALS TO ORDER
And at most reasonable rates.

HOT COFFEE AND TEA, SANDWICHES, LEMONADE, MILK, LUNCHES, &c.

Fresh N. Y. Count Oysters always on hand.

OVER. S. LITTLE & CO., Prop.

In the Victorian era, oysters were a popular menu item at many restaurants. Little's, which appears in only the 1895 Canton city directory, advertised "fresh NY count oysters always on hand" in all seasons.

Ed and Anna Bender opened their well-known restaurant in 1902 at the corner of East Tuscarawas Street and Walnut Avenue. In 1907, it moved to its present location in the Belmont Building, which was designed by architect Guy Tilden. In spite of a major fire in 1988, the original bar is still intact.

EAT AT BENDER'S

MEN'S RESTAURANT LUNCH COUNTER
LADIES RESTAURANT

Positively no Liquors served in Lunch Counter or Ladies Restaurant

This advertisement from 1918 points out that "positively no liquors" were served in the Ladies Restaurant. Saturday nights in the 1910s were often described as "nightmares" by the staff, who dreaded them all week long. Downtown stores were open late, and businessmen often had wives and children meet them for dinner. After an evening of shopping, they all came back for "chili and beer" and stayed well into the night. The Jacob family purchased the restaurant from Anna Bender in 1932. Today, it is run by the fourth generation of the family.

Halliwell's was located at 13 East Tuscarawas Street near Public Square. The restaurant was "centrally located," noted one Canton souvenir booklet in 1907, "yet above the din and noise of the street" because it was on the second floor. G.E. Halliwell "won a reputation for the best meals money can buy and where everything is clean and well cooked, meals served in good style, and every customer given prompt attention." Halliwell also operated a lunch counter called the Exchange around the corner from his first restaurant. (Courtesy of the Stark County District Library.)

Roth & Hug was a popular corner drugstore and soda fountain in the early 20th century. In 1899, Charles R. Roth and Casimer K. Hug had bought a small drugstore at 333 East Tuscarawas Street from H.H. Ink, and they quickly grew their business into a local chain. This is the 435 East Tuscarawas Street location.

By 1922, there were at total of seven Roth & Hug locations in Canton: East Tuscarawas Street and Cherry Street NE, Market Avenue and Second Street NE, Cleveland Avenue and Twelfth Street NW, the Harris Arcade Building, Cherry Street and Second Street NE, Market and Sixth Street NW, and Tuscarawas Street and High Street SW. There was also a location in North Canton.

In 1917, Roth & Hug ran the following advertisement: "We have sold 5-cent soda for seventeen years and it is with regret that we find a good ice-cream soda can no longer be served for that amount. Fruit, fruit juices, flavors, sugar, ice cream, service, all have been steadily advancing for years . . . we have to do one of two things—cheapen quality or raise the price . . . so we are forced to serve 10-cent soda."

The first effort at creating a resort at Meyers Lake began in 1879 when Joseph A. Meyer, grandson of Andrew Meyer, built the Lake Park Hotel. Like so many early ventures, the hotel burned down in 1892. It was rebuilt by the Reymann Brewing Company and was then sold to the Northern Ohio Traction & Light Company, who leased it to the Lakeside Country Club in 1903. The country club's dining room is shown here.

95

TULLY FOSTER'S CASABLANCA COCKTAIL LOUNGE
ON ROUTE 30 BETWEEN CANTON AND MASSILLON

PLANTER'S PUNCH
1 oz. lemon or lime juice, 1 teasp. sugar, 1 jigger Jamaica rum. Shake well with fine ice and pour unstrained into 10-oz. glass. Decorate with slice of orange, lemon, cherry and sprig fresh mint.

GIN RICKEY
Juice and rind of ½ lime. Cube of ice. 1 jigger of gin. Fill with club soda.

SLOE GIN FIZZ
1¾ oz. lemon juice, 1 teasp. sugar, 1 jigger sloe gin. Shake well with cracked ice and strain into highball glass. Fill with ice-cold soda.

MINT JULEP
In 10-oz. glass muddle few sprigs fresh mint with 1 teasp. sugar and splash of soda. Fill glass with fine ice and pour in 1½ oz. of bourbon. Set glass into container and pack tightly with fine ice. Stir mixture briskly for minute to freeze ice to outside of glass. Lift out and decorate with 2 sprigs mint, slice of orange, lemon and a cherry. Fine powdered sugar dusted over mint adds to frosted appearance of drink.

SINGAPORE SLING
1 oz. lemon juice, ½ oz. gin, 1 oz. cherry brandy. Shake well with cracked ice and pour unstrained into 10-oz. glass. Decorate with slice of orange, lemon and a cherry.

TOM AND JERRY
1 whole egg, 1 teasp. sugar, 1 pinch salt. Mix by hand or electric mixer. Add 1 jigger of rum. Pour mixture into glass mug. Add boiling water slowly while stirring to prevent egg from curdling. Sprinkle nutmeg on top.

HOT TODDY
In glass mug place the following: 1 lump sugar, 1 stick cinnamon, 3 cloves stuck into slice of lemon, 1 jigger of rum, whisky or brandy. Leave silver spoon in glass to prevent heat from cracking it. Add boiling water.

SIDE CAR
½ oz. lemon juice, ¾ oz. brandy, ¾ oz. Cointreau or triple sec. Shake well with cracked ice and strain into cocktail glass.

OLD FASHIONED
1 lump sugar saturated with bitters, splash of soda, muddle. 1 cube of ice, 1 slice of orange, lemon and a cherry. Over this pour 1 jigger of rye, bourbon or Scotch whisky.

MANHATTAN
½ sweet vermouth, ⅔ rye or bourbon whisky, bitters if desired. Stir with cracked ice and strain. Serve with cherry.
DRY MANHATTAN: Dry instead of sweet vermouth.

SHERRY FLIP
1 whole egg, 1 teasp. sugar, 1 jigger sherry. Shake well with cracked ice and strain into Delmonico glass. Sprinkle nutmeg on top. Brandy or port may be used instead of sherry.

EGGNOG
1 whole egg, 1 teasp. sugar, 5 oz. milk, 1 jigger liquor (brandy, whisky, rum or sherry mostly used). Shake well with cracked ice and strain. Sprinkle grated nutmeg on top.

FROZEN DAIQUIRI
½ oz. lemon or lime juice, ½ teasp. sugar, dash maraschino liqueur, 1¾ oz. white rum. Mix chilled with fine cracked ice on electric mixer or shake well by hand. Pour unstrained into champagne "saucer". Top with a cherry.

DAIQUIRI
½ oz. lemon or lime juice, ½ teasp. sugar, 1 jigger white rum. Shake well with cracked ice and strain.

DUBONNET COCKTAIL
1 oz. gin, 1½ oz. Dubonnet. Stir with cracked ice and strain. Top off with a twist of lemon peel.

Before shifting gears and starting an all-you-can-eat restaurant called Town and Country, Mary and Tully Foster ran the Club Casablanca at the same location (5079 West Tuscarawas Street) from 1942 to 1957, hosting such big-name stars as Lawrence Welk and Patti Page. Once television began to replace live shows, the Fosters decided to switch gears. They had seen a buffet in a hotel in Toronto where the chefs served the food in the style of a cafeteria, and they decided to give it a try here.

When the Fosters opened their famous buffet Town and Country in 1957, it was the first of its kind in the area. Serving fantastic food and charging just $2.50 per person, the crowds started to become a problem. They actually raised their price to try to reduce the number of customers. Town and Country closed in 1987 when the Fosters retired, and the building was razed in 2001. (Courtesy of Linda Todd.)

Founded by Nick Zenallis in 1956, Nick's Place Topp's Chalet was one of the first businesses built in what would become the bustling Belden Village area, at 5401 Whipple Avenue NW. It was a fine-dining establishment where people often went to celebrate special occasions. The restaurant burned down in May 1994 and was not rebuilt.

Emmanuel "Mike" Elite and George Bourlas ran the Elite Restaurant at 206 West Tuscarawas Street from 1932 until 1957. It was open 24 hours a day, with each partner taking a 12-hour shift. Tommy Dorsey, Guy Lombardo, Desi Arnaz, and Howard Hughes were just a few of the familiar names who ate at the Elite. During the Depression, the owners were known to feed people who were down on their luck from the back door. (Courtesy of Jim McVay.)

A native of Greece, Frank Michael Mergus began his career as a kitchen boy in Boston's Hotel Touraine when he was just 14. Shortly after coming to Canton, he started working at Bender's in 1923. In 1930, he went to work at the Onesto Hotel as a caterer. In 1943, he opened Mergus Restaurant at 225 West Tuscarawas Street. One advertisement stated that Mergus was "known everywhere as one of Ohio's outstanding restaurants."

The most popular dishes at Mergus were prime rib, lobster, and charcoal-broiled steaks. The restaurant became known as a special place to host wedding receptions, engagement dinners, and banquets. In the 1960s, pianist Betty Geouge entertained diners nightly. After Mergus's death in 1980, the restaurant was sold. It continued to operate under new ownership for three years before closing. (Courtesy of Linda Todd.)

Visit Mergus RESTAURANT
One of Ohio's Dining Places of Distinction

Beautiful New **Heritage Room** for gracious dining

An extensive menu with superb service in both dining rooms.

Driftwood Room & COCKTAIL LOUNGE
A club-like atmosphere for cocktails and dinner

SPECIAL PARTY ROOMS
Grill Room for Stag Parties
Gallery Room
Garden Ball Room for 25 to 450 people

PIANO STYLINGS nightly by Betty Geouge

FREE PARKING — PARKADE
W. Tusc. at Cleveland Ave.
DRIVE IN

OPEN DAILY UNTIL 1:00 A.M. - Closed Sunday
FOR RESERVATIONS CALL 453-7688
225 W. Tuscarawas • 220 2nd Street, N.W.

Balto., Md. Made in U. S. A.

TOASTED BUNS
ON BUTTERED
SANDWICHES
SODAS & SUNDAES
FROZEN CUSTARD

3232 CLEVELAND, N.
CANTON, OHIO

AVALON

TRAY SERVICE

DINING ROOM

AVALON AVALON

CLOSE COVER BEFORE STRIKING

The first drive-in carhop-service restaurant in the area was Avalon's, located at the time quite a distance out of town on Cleveland Avenue, north of Thirtieth Street. Brothers A.A. "Sykes" and Gerald Thoma built it in 1935 and named it after a Pacific Island paradise they had heard about on a visit to the west coast. The menu featured frozen custard (a novelty at the time), sandwiches, and their signature burger, "Big Sis." Cruising was elevated to an art form in the 1950s, and kids would "Buzz the A" to see what was going on, even if they did not have any money or were not particularly hungry. The Avalon closed in the 1970s to make room for a Wendy's. (Courtesy of the Canton Classic Car Museum.)

There were two other Avalon locations, one at Ninth Street and North Market Avenue, shown here, and another at Dueber Avenue and West Tuscarawas Street. (Courtesy of Jim McVay.)

This 1949 Avalon children's menu came from the North Market location. Main-entrée options were creamed chicken or roast veal with a starter of beef rice soup, sides of buttered peas and whipped potatoes, and a choice of tomato juice or apricot nectar—much different from modern children's menus featuring hot dogs and chicken nuggets. (Courtesy of Dawn Walter.)

KOZY KITCHEN DRIVE-IN RESTAURANT
AIR-CONDITIONED

CORNER W. TUSC. AND DUEBER GL 4-3309

OVEN FRIED CHICKEN
With Home Made Dressing

BAKED SWISS STEAK
With Rich Brown Gravy

$1.00 COMPLETE DINNERS

Many, many more delicious meals on our menu.

The Kozy Kitchen was located on the southwest corner of West Tuscarawas Street and Dueber Avenue, where Lindsey's is now located. Like many drive-ins, there were carhops at the Kozy Kitchen, but customers could also eat inside the air-conditioned dining room. It was one of many teen hangouts in the 1950s and 1960s. (Courtesy of Linda Todd.)

Eckard's, located at the corner of West Tuscarawas Street and Linwood Avenue SW, was a popular hangout for Lincoln High School kids. In 1949, Eckard's became the first in the area to have carhops on roller skates who served patrons in their cars. Alternatively, customers could go inside and eat at a booth. In the 1960s, one could get a Coke and French fries for 35¢. Eckard's closed in 1968, when drive-ins were beginning to be replaced by drive-throughs. (Courtesy of Jim McVay.)

The LakeShore

RESTAURANT
Located In Front Of Moonlight Ballroom

Open Sunday 11:30 A.M.

SUNDAY, JUNE 3rd DINNER SPECIALS
Beef Pot Roast $1.50
Breaded Pork Tenderloin $1.50
Braised Swiss Steak $1.50
Roast Chicken with Dressing $1.50

(Children's Dinners Only $1.00)

Ph. GL 2-0229 Meyers Lake Canton

With a beautiful view of Meyers Lake, the Lakeshore Restaurant was conveniently located adjacent to the Moonlight Ballroom, providing the setting for an ideal date night. George C. Sinclair opened the restaurant in August 1961, and it featured dining and cocktails all year round. The restaurant closed in August 1976 but later reopened as Clancy's. It was destroyed in the January 1979 fire that engulfed the Moonlight Ballroom. (Courtesy of Linda Todd.)

OPEN 6:30 A.M. TO 8 P.M.

ARCADE RESTAURANT
First Class Food
First Class Service
112 Piedmont Avenue S. E.
CANTON, OHIO
ROBERT HALL, Prop.

I am hungry So am I I was So was I You won't be if you eat here
HUNGRY - - - - *You EAT HERE*
You are going to be hungry after a while—
You will want something to eat,
And what you get will make you smile, at
New Barnett Restaurant & Dairy Lunch

Eat At Benders
BENDERS SERVICE RESTAURANT
Court and Second S. W.
BENDERS CAFETERIA
118 Market Ave. S.

L. E. EVANS
EAT AT
THE GRAND RESTAURANT
McKinley Hotel Building
GOOD SERVICE
318 Market Ave. S. Canton, Ohio

YOU WILL ENJOY EATING AT
THE
Y. M. C. A. CAFETERIA
GOOD WHOLESOME FOOD
MODERATE PRICES

Visiting Odd Fellows
On your short stay in Canton, for home cooked meals, quality and service, yet at 1917 prices, you should eat at
LUNCH
THE HORSE SHOE DAIRY
Second door east from the Square at Tuscarawas St. E.

BATES' CANDY SHOP
Lunch, Candy and
Ice Cream
213 Market North

HOTEL COURTLAND
CANTON, OHIO
POPULAR PRICED LUNCH ROOM
Opening Into Lobby of Hotel
Also Tables for Ladies and Gentlemen

JERSEY RESTAURANT
On the Square 104 Market N. E.
AND
PALACE RESTAURANT
The Best of Everything to Eat

CRESCENT RESTAURANT
134 Tusc. W.
We Welcome All Odd Fellows and
Ladies
FIRST CLASS SERVICE

MANHATTAN RESTAURANT
236 Market Ave. S.
All Odd Fellows Calling At Our
Restaurant Will Call Again
TABLES FOR LADIES

Experienced Manager Always in Attendance 314 W. Tusc. St.
NEXT TO CENTRAL SAVINGS BANK

The General Committee
Recommends These Restaurants
to Their Friends

This advertisement appeared in the program for the Grand Encampment and Department Council of the Independent Order of Odd Fellows (IOOF) in July 1921. It shows the variety of dining options available in downtown Canton at that time, including Bender's, the YMCA Cafeteria, the Hotel Courtland, the New Barnett Restaurant and Dairy Lunch, the Grand Restaurant, Bates' Candy Shop, Crescent Restaurant, Manhattan Restaurant, the Horse Shoe Dairy, Jersey Restaurant, and the Palace Restaurant. (Courtesy of the Canton Classic Car Museum.)

GLAZED DONUTS 60¢ doz.

Mary Ann DRIVE-IN DONUT SHOPPE

1009 McKINLEY AVE. NW. DIAL GL 5-5609

Peter and Mary Edna Welden opened the first Mary Ann Donuts location at 1009 McKinley Avenue NW in 1947. It was named for the couple's first child, Mary Ann. A second location opened on West Tuscarawas Street in 1984. The family-owned local chain has grown to seven stores in Stark County, and their donuts can be found in a variety of convenience stores and gas stations throughout Northeast Ohio. According to this advertisement from 1962, a dozen Mary Ann donuts cost just 60¢. (Courtesy of Linda Todd.)

Dick Logan's was located at 201–203 Twelfth Street NE. The family's original name, Lougash, was Americanized to Logan. In 1969, the booklet Around Town said, "The piano bar at Dick Logan's is alive nightly under the talents of Gene Wygant. The personable pianist covers the gamut on the musical scale from blues, jazz to old-time favorites. If you feel like singing, join in, everybody else does." (Courtesy of Linda Todd.)

FOOD FOR THOUGHT

Dick Logan's

HOUSE OF FINE BEEF

WE OFFER YOU THE ULTIMATE IN FACILITIES & SERVICE FOR YOUR BANQUET OR PARTY.....
- LARGE & SMALL PRIVATE ROOMS FOR GROUPS OF 8 TO 250
- FREE PARKING ADJACENT TO BUILDING FOR 150 CARS
- FINE COCKTAILS—*Imported* WINES & BEERS
- ONE OF CANTON'S MOST COMPLETE DINNER MENUS

All credit cards honored

201 12th St., N.E. *call* 456-2768

"CANTON'S ORIGINAL HALL OF FAME ROOM"

At the Linway, customers could order "a complete meal or just a snack." They were well known for their freshly baked pastries. The Linway was located at 5103 West Tuscarawas Street, one mile west of Canton, and it appeared in the Canton city directory from 1942 to 1956. (Courtesy of Jim McVay.)

The Candy Bowl was a favorite stop after a long day of shopping or catching a movie in one of the downtown theaters. The sandwich shop and ice-cream parlor was located at 330 North Market Avenue and was open from 1950 to 1973. (Courtesy of the Stark County District Library.)

The Boston Restaurant, located at 1318 West Tuscarawas Street, appeared in the Canton city directories from 1924 to 1942. (Courtesy of Dawn Walter.)

Located at 2231 Forty-fourth Street NW, the Pines was a favorite spot for weddings from the 1950s through the mid-1980s. John Salby, the original owner, lived upstairs and later built a house next door. From 1984 to 1989, Ron Kern ran a restaurant called Whitehouse Chicken in the space. Michelle and Shawn McCartney purchased the building in 1991 and, after six months of renovation, they reopened as Chateau Michele on their wedding day, February 14, 1992. The banquet hall is a popular spot for wedding receptions, parties, meetings, and catering. (Courtesy of Chateau Michele.)

Originally opened as a Barnhill's franchise in 1970, the ice-cream parlor at 4216 Hills & Dales Road NW became Butler's in 1975. The restaurant was decorated in 1890s style, with wrought-iron chairs, marble-top tables, and Tiffany lamps. The restaurant was known for its extra-large menu items. A "Party Soda" was served in a one- or two-gallon brandy snifter with a 36-inch-long straw for each person. The "Sociable Soda" was available for two, four, eight, or twelve people. And the colossal "Hall of Fame Sundae" fed 50 to 75 people, with nine gallons of ice cream, one and a half gallons of syrup and toppings, four cans of whipped cream, a quart of cherries, and a dozen bananas. Butler's closed in 1988. (Courtesy of the Stark County District Library.)

Taggart's was founded in 1926 at 1401 Fulton Road NW, where it still operates today. The beloved ice-cream parlor is famous for the Bittner, a Canton favorite since 1931. Named for a delivery boy, the secret mix of vanilla ice cream, chocolate syrup, and pecans creates a dessert that is the consistency of a milkshake but thick enough to eat with a spoon. The Bittner comes in two sizes: regular or the mini version shown here. (Courtesy Barbara Abbott, Canton Food Tours.)

Eight
SHOPPING

Julius Thurin opened his first store in Louisville, Ohio, in 1878. Thurin's moved to Canton in 1918 and became a prominent home-furnishings store in the community. Originally located at the northeast corner of Piedmont Avenue NE and Second Street, Thurin's moved to 524 North Market Avenue in 1925. In later years, the company opened additional locations at 137 Sixth Street NE, Country Fair Shopping Center at 4105 West Tuscarawas Street, and Hillsdale Shopping Center at 2821 Whipple Avenue. The Market Avenue location was razed in 1977, along with Loew's Theatre, to make room for the Canton Towers apartments.

Livingston's was located on the bottom floors of the Renkert building on the corner of Market Avenue and Third Street NE, where the Kenny Bros. Store was originally located. The 10-story building is constructed of four-inch paving brick and has a footprint of 42 by 200 feet. A 1963 Livingston's advertisement in a Player's Guild program for the production of *Guys & Dolls* said, "When you shop here . . . you'll find it most rewarding to browse around our store without distraction and in pleasant surroundings." The store offered an interior-decorating service to customers at no charge.

Vicary's was a leading clothing store for Canton's fashionable men for many years. When the Union Clothing Manufacturing Company folded in 1891, C.N. Vicary was appointed liquidation administrator and came to Canton from LeRoy, New York. He and a partner opened the small tailor shop and men's store shown here at 38 and 40 North Market Avenue. As the business grew, Vicary's moved to 228–234 North Market Avenue, where the Parisian was later located, and then relocated to 314 North Market Avenue. Vicary's moved to Belden Village in 1970.

Stern & Mann, Canton's legendary department store, opened in 1887 when Max Stern and Henry Mann bought Winterhalter Millinery Store on South Market Avenue. When they first opened, Stern & Mann sold mostly hats but also stocked ribbons, buttons, fabric, and some dressmaking supplies. The clerks were stationed behind the counters and did not roam the floor helping customers. Stern & Mann moved to a colossal new building on the corner of Cleveland Avenue and Tuscarawas Street in 1925, shown here. Four generations of the family operated the store before the doors finally closed in the early 1990s.

J.C. Penney leased space at 201 North Market Avenue in 1933. The department-store chain started in Kemmerer, Wyoming, in 1902, and by 1943 there were locations in every state. During McKinley's time, the building housed a department store called Zollinger's. J.C. Penney became an anchor store of the new Mellett Mall (now Canton Centre) in 1965, where it is still located today.

109

Kobacker's opened at 501 North Market Street in 1935. The building had been built by Frank Case in 1920 and originally housed the Klein-Heffleman Company and Ross stores. At first, Kobacker's leased the building, but in 1941 the department store's owners decided to purchase it. Kobacker's carried everything from women's fashions and menswear to curtains, rugs, and blankets for the home.

Maurice Rapport, a Russian immigrant, owned a chain of women's clothing stores in Western Pennsylvania and Northeast Ohio. The Canton store was located at 500 North Market Avenue. Rapport also owned the Town Shop, located on the first floor of the Onesto Hotel. A 1963 Rapport's advertisement in a Player's Guild program featured the slogan "Fashions for Daytime, Playtime and Datetime."

Located at 301 Market Avenue South, Simpson's Cigar Store was a popular gathering place for almost 60 years, particularly among sports enthusiasts. When it closed in 1950, Simpson's housed Stark County's only sports ticker. Customers could check the store's large scoreboard for whatever sport was in season, from inning-by-inning baseball scores to college-football results. The store also carried unusual brands of tobacco. Its founder, W.R. Simpson, was quite fond of creative marketing stunts and once purchased a cow that he tied up outside his store in the heart of downtown Canton.

Frank Winfield Woolworth opened his first successful store in Lancaster, Pennsylvania, in 1879. Woolworth's, the first "5 and 10 cent" department store, grew to over 3,000 stores across the globe. Canton's first Woolworth store opened at 221 South Market Avenue in 1913. Three years later, a second location opened at 221 North Market Avenue. Over the years, more stores opened across town, and Woolworth's was one of the original tenants when Mellett Mall (now Canton Centre) opened in 1965. The original downtown store closed in 1960, and the mall location closed in 1994.

Shortly after Woolworth opened his first store, John G. McCrory opened his own "5 and 10" in Scottsdale, Pennsylvania, in 1882. McCrory originally spelled his name "McCrorey," but he was so frugal he legally dropped the *e* in order to spend less money on lettering for his store signs. The chain also grew quickly, operating more than 1,000 stores at the height of the chain's popularity. McCrory's was originally located at 227 North Market Avenue in Canton in 1925. In 1987, it opened in the old Kresge Department Store location at 301 North Market. It closed in 1995.

William Thomas Grant opened his first variety store in Lynn, Massachusetts, in 1906. When he died in 1972, there were almost 1,200 W.T. Grant stores nationwide. The Canton location opened in 1925 at 401 North Market Avenue.

Rhea Davis worked at Mary Lee Candies in 1939. At the time, there were two Mary Lee Candies locations—212 and 439 North Market Avenue—and they were part of a larger chain of candy stores with locations in Akron, Canton, Cincinnati, Cleveland, Columbus, Dayton, Elyria, Lakewood, Painesville, Sandusky, Springfield, Toledo, and Warren, as well as Michigan and West Virginia. The store at 212 North Market Avenue appears in the Canton city directory from 1927 to 1939. The second location is listed from 1939 to 1948. (Courtesy of Dawn Walter.)

By the 1940s, downtown Canton was a bustling shopping district with lots of traffic (both cars and pedestrians). Dozens of stores—small and large—lined Market Avenue. One of the most popular shops in the above photograph was Shirley Shoes, located at 214 North Market Avenue. A 1955 advertisement in the sesquicentennial commemorative booklet for the beloved shoe store read, "Where matching beautiful shoes with accessories is a fine art." (Above, courtesy of Jim McVay; below, courtesy of Al Longbrake.)

The Ohio-based department-store chain Halle Bros. began in Cleveland as a small fur shop and millinery in 1891. The Canton store opened in 1930 at 624 North Market Avenue. Halle's is remembered fondly for its superior service and high-quality merchandise. The store operated in downtown Canton for 25 years and returned to Canton in 1970 when the chain opened a location at Belden Village. That store was closed in 1982.

The first Polsky's store sold dry goods in Akron in 1885. After a traveling salesman sold the owners some ready-to-wear women's skirts, the store became a leading source for women's fashions. Polsky's opened its Canton stores in 1955, purchasing the Halle Brothers locations in downtown Canton and at the Country Fair Shopping Center. Another location later opened at Mellett Mall, but in 1978 all four Polsky's stores—downtown Canton, Mellett Mall, Akron, and Fairlawn—closed. (Courtesy of Jim McVay.)

Many Cantonians have fond memories of the elaborate window displays in downtown department stores during the holidays. This child stares in wonderment at the array of Christmas gifts in Polsky's window in the early 1960s. (Courtesy of Al Longbrake.)

Mellett Housing Project was named after newspaperman Don Mellett, who was gunned down in his driveway in 1926 for exposing organized crime. The project was a series of barracks-like apartment buildings constructed by the federal government in the 1940s as homes for workers at the Westinghouse Naval Ordnance Plant. The homeowners joined together to develop a shopping center. In 1963, they announced plans for a 300,000-square-foot mall on 33 acres on the southwest corner of West Tuscarawas Street and Whipple Avenue SW. J.C. Penney and O'Neil's signed on to become anchor stores, and the mall opened in 1965. (Courtesy of Jim McVay.)

Originally, the mall consisted of six separate buildings in an open-air configuration. A roof was added later. Original stores included Gray Drugs, Betty's Beauty Salon, Cleveland Fabric Shops, Norman's Shoes, Sherwin-Williams, Troy Laundry and Dry Cleaning, Woolworth's, London's Candies & Ice Cream, and Montgomery Ward. Over the next few years, several downtown department stores—including Harvard Clothing Store and Rapport's—opened satellite stores in the Mellett Mall. Though many reaffirmed their commitment to downtown, it was becoming clear that the future of the retail industry would be concentrated in the growing suburbs. The name of the mall was changed to Canton Centre in 1981. (Courtesy of Jim McVay.)

Plans for a new shopping mall on the outskirts of town in Jackson Township were announced on June 23, 1966, with Higbee's and Sears as its anchor stores. Although some were worried about the effects on the downtown shopping district, plans for Belden Village Mall went ahead, and it opened on October 1, 1970.

Nine

SPORTS

The first local professional baseball teams in Canton played from 1887 to 1888 and in 1892 in the Ohio State League. Over the years, Canton teams have been part of the Tri-State League, Central League, Ohio-Pennsylvania League, Inter-State League, Buckeye League, and Middle Atlantic League, according to James P. Holl, author of *The Canton Terriers*. This unidentified Canton team is likely from one of the earliest ball clubs in the late 19th century.

119

The Pennsylvania Railroad team, pictured here in 1920, likely played at the new Meyer's Lakeside Athletic Park, built on the site of the old League Park. The facility hosted professional football games as well as sandlot baseball teams. Canton's last professional baseball team played at Lakeside from 1936 to 1942. Walter Lash won the team's naming contest with "Canton Terriers," noting that terriers are "scrappy, alert and full of pep," and the designation was chosen to parallel the football team, the Bulldogs.

In 1903, A.J. Dysle operated the Grand Bowling Alleys at 125 East Eighth Street (which became Third Street SE when the downtown streets were renumbered in 1913). Acme Bowling Alley & Pool Parlor was located at Third and Market Streets in the Martin Block. In October 1907, the City Bowling League had eight teams—the Tabernacles, Grands, Acmes, Simpsons, Stetsons, Athletics, Hardly Ables, and Entre Nous. The bowlers in this photograph are unidentified.

This photograph was taken at Canton Recreation Lanes in the 1940s. Pictured from left to right are (first row) Elmer, Evelyn, Eva, and Ed Stuckey; (second row) Cora and Helen Stuckey. By 1943, Canton boasted 11 bowling alleys and more than 600 teams sanctioned by the American Bowling Congress. In the 1950s, bowling expanded nationwide with the invention of the automatic pinsetter and national television coverage of bowling tournaments. (Courtesy of Linda Todd.)

Located at Meyers Lake, the Lakeside Country Club opened one of the earliest golf courses in Canton in the spring of 1903. This postcard shows the locker house and ninth green of the nine-hole course, designed by Tom Bendelow. Today, Stark County is known as "Ohio's Golf Capital" because there are 21 golf courses within its borders. Canton has five public golf courses—Glenmoor Country Club, Meadowlake Golf & Swim, Skyland Pines Golf Club, Tam O'Shanter Golf Course, and the Quarry Golf Club. East Canton is the home of Clearview Golf Club, the first course designed, built, owned, and operated by an African American.

In 1906, the team pictured here won Canton's city championship in roller polo, which was a game similar to hockey but played on roller skates and with a round ball rather than a puck. The team was sponsored by a cigar-making company in town and was made up of young men from the "Limerick" neighborhood in Canton's southwest section. Local roller polo teams played each other at the Auditorium. Pictured here from left to right are (first row) Kidder Baxter, team manager Fred Bellinski, and Leo Fisher; (second row) William Burnosky, Claude Feightner, and Albert Elkins.

Canton's first professional football team, the Athletics, was coached by William L. Day, son of William R. Day. He used home talent in combination with semiprofessional or strictly amateur players. In 1904, the team started securing college players for weekend games, and Coach Day organized the Canton Athletic Club to help fund Canton's football, baseball, and basketball teams. In 1906, the Athletics became the Bulldogs. The rivalry between Canton and the Massillon Tigers was in full swing by then, with both communities supporting the teams financially and packing the stands for games.

After a nine-year hiatus, professional football returned to Canton in 1915 when Ray McGregor and Ben Clark started another team. According to Stark County historian E.T. Heald, the Canton-Massillon games in this new era were "hard fought and fairly played." Jim Thorpe came to town that year to play in two games with the Bulldogs. By this time, most of the home talent had been replaced by imported players from around the country. The venerable Thorpe led the Canton Bulldogs to their first World Championship in 1919.

The Canton Bulldogs won back-to-back world championships in 1922 and 1923. After the 1923 season ended, the team was bought out and moved to Cleveland.

123

The rivalry between the McKinley Bulldogs and the Massillon Tigers that still exists today began with the professional football teams. The high school teams adopted those names after the professional teams left for larger cities in the 1920s.

Judy Hively, Barb Nicholson, and Betty McCauley stand by a car decorated for the 1961 Massillon-McKinley game. After the departure of the professional teams, high school football quickly became a major pastime for both communities. Yearly matches between the rival teams have attracted large audiences and captured the attention of almost everyone in town for nearly a century. Today, the annual Massillon-McKinley game is a nationally recognized event in high school football. (Courtesy of Linda Todd.)

In 1935, Canton lost a beloved civic leader when John A. Fawcett died of pneumonia. Fawcett was the president of the First Trust & Savings Bank and an avid McKinley Bulldogs fan. The John A. Fawcett Stadium opened in 1938. The McKinley Bulldogs played the Lehman Polar Bears in the first game at the stadium, which had seating capacity for 20,000. Official opening ceremonies took place the following year when the $250,000 project was completed.

In 1920, the Professional Football League was formed in Ralph Hay's Hupmobile dealership at Cleveland Avenue and Second Street SW in Canton. Hay owned the Canton Bulldogs. The objectives were to unify scattered teams, prevent contract jumping, and regulate the sport's rules. Since Canton was the home of the first organized professional football league, it was an ideal location for the Pro Football Hall of Fame. Construction on the new museum began in 1962.

From the beginning, the Pro Football Hall of Fame has sponsored an elaborate grand parade to celebrate the enshrinees. This photograph, featuring the Massillon Tigers mascot, was taken during the first parade in 1963. (Courtesy of Linda Todd.)

Each parade features floats, marching bands, and other units, such as the antique automobile shown in this photograph from the 1977 event. Enshrinees past and present ride in convertibles with their names displayed on the side. The original enshrinement gallery was designed for 34 individual tributes to be chosen by the sports media, with an annual induction size of two or three players as in the Baseball Hall of Fame. It would have been adequate for at least two decades, if the charter class had not consisted of 17 players. Over the years, there have been several expansion projects to accommodate the growing museum.

Brothers Guy Walter (left) and Gary Walter (right) were thrilled when their favorite teams came to town for the 1979 Hall of Fame game. Hall of Fame founders pitched the idea of a Hall of Fame game, modeled after the one held annually at the Baseball Hall of Fame, and the National Football League loved the idea. It was decided that teams from outside Ohio should play in the first game, so the New York Giants and St. Louis Cardinals were invited to Canton. They played to a 21-21 tie. (Courtesy of Dawn Walter.)

Community volunteers and Hall of Fame officials work together to organize the annual Hall of Fame Festival, drawing thousands of visitors from across the country during the two weeks leading up to the enshrinement. In addition to the Grand Parade, the Hall of Fame Festival includes a fashion-show luncheon, two- and five-mile running races, fireworks, a concert, a food festival, and a hot air–balloon classic. The three-day ribs burn-off, shown here, was originally staged in downtown Canton but was moved to the Stark County Fairgrounds in 2003. (Courtesy of Dick Fulton.)

Discover Thousands of Local History Books
Featuring Millions of Vintage Images

Arcadia Publishing, the leading local history publisher in the United States, is committed to making history accessible and meaningful through publishing books that celebrate and preserve the heritage of America's people and places.

Find more books like this at
www.arcadiapublishing.com

Search for your hometown history, your old stomping grounds, and even your favorite sports team.

Consistent with our mission to preserve history on a local level, this book was printed in South Carolina on American-made paper and manufactured entirely in the United States. Products carrying the accredited Forest Stewardship Council (FSC) label are printed on 100 percent FSC-certified paper.

MADE IN THE USA